8/17

www.macat.com
info@macat.com

Cover illustration: Capucine Deslouis

Cataloguing in Publication Data
A catalogue record for this book is available from the British Library.
Library of Congress Cataloguing-in-Publication Data is available upon request.

ISBN 978-1-912302-90-1 (hardback)
ISBN 978-1-912127-06-1 (paperback)
ISBN 978-1-912281-78-7 (e-book)

Notice
The information in this book is designed to orientate readers of the work under analysis,
to elucidate and contextualise its key ideas and themes, and to aid in the development
of critical thinking skills. It is not meant to be used, nor should it be used, as a
substitute for original thinking or in place of original writing or research. References and
notes are provided for informational purposes and their presence does not constitute
endorsement of the information or opinions therein. This book is presented solely for
educational purposes. It is sold on the understanding that the publisher is not engaged
to provide any scholarly advice. The publisher has made every effort to ensure that
this book is accurate and up-to-date, but makes no warranties or representations with
regard to the completeness or reliability of the information it contains. The information
and the opinions provided herein are not guaranteed or warranted to produce particular
results and may not be suitable for students of every ability. The publisher shall not be
liable for any loss, damage or disruption arising from any errors or omissions, or from
the use of this book, including, but not limited to, special, incidental, consequential or
other damages caused, or alleged to have been caused, directly or indirectly, by the
information contained within.

CONTENTS

THE MACAT LIBRARY

The Macat Library is a series of unique academic explorations of seminal works in the humanities and social sciences – books and papers that have had a significant and widely recognised impact on their disciplines. It has been created to serve as much more than just a summary of what lies between the covers of a great book. It illuminates and explores the influences on, ideas of, and impact of that book. Our goal is to offer a learning resource that encourages critical thinking and fosters a better, deeper understanding of important ideas.

Each publication is divided into three Sections: Influences, Ideas, and Impact. Each Section has four Modules. These explore every important facet of the work, and the responses to it.

This Section-Module structure makes a Macat Library book easy to use, but it has another important feature. Because each Macat book is written to the same format, it is possible (and encouraged!) to cross-reference multiple Macat books along the same lines of inquiry or research. This allows the reader to open up interesting interdisciplinary pathways.

To further aid your reading, lists of glossary terms and people mentioned are included at the end of this book (these are indicated by an asterisk [*] throughout) – as well as a list of works cited.

Macat has worked with the University of Cambridge to identify the elements of critical thinking and understand the ways in which six different skills combine to enable effective thinking.
Three allow us to fully understand a problem; three more give us the tools to solve it. Together, these six skills make up the **PACIER** model of critical thinking. They are:

ANALYSIS – understanding how an argument is built
EVALUATION – exploring the strengths and weaknesses of an argument
INTERPRETATION – understanding issues of meaning

CREATIVE THINKING – coming up with new ideas and fresh connections
PROBLEM-SOLVING – producing strong solutions
REASONING – creating strong arguments

To find out more, visit **WWW.MACAT.COM.**

CRITICAL THINKING AND *A VINDICATION OF THE RIGHTS OF WOMEN*

Primary critical thinking skill: CREATIVE THINKING
Secondary critical thinking skill: REASONING

Mary Wollstonecraft's 1792 *Vindication of the Rights of Women* is an incendiary attack on the place of women in 18th-century society.

Often considered to be the earliest widely-circulated work of feminism, the book is a powerful example of what can be achieved by creative thinkers – people who refuse to be bound by the standard ways of thinking, or to see things through the same lenses that everyone else uses. In the case of the *Vindication*, Wollstonecraft's independent thinking went directly against the standard assumptions of the age regarding women.

During the seventeenth century and earlier, it was an entirely standard point of view to consider women as, largely speaking, uneducable. They were widely considered to be men's inferiors, incapable of rational thought. They not only did not need a rational education – it was assumed that they could not benefit from one. Wollstonecraft, in contrast, argued that women's apparent triviality was a direct consequence of society failing to educate them. If they were not men's equals, it was the fault of a society that refused to treat them as such. So radical was her message that it would take until the 20th century for her views to become truly accepted.

ABOUT THE AUTHOR OF THE ORIGINAL WORK

Writer and philosopher **Mary Wollstonecraft** was one of the key thinkers in the development of feminism. Born in London in 1759, she was a supporter of radical politics and a champion of the ideas behind the French Revolution. The publication of *A Vindication of the Rights of Woman* in 1792 would eventually see her celebrated as a symbolic figure in the achievements of women, although it would be many years after her death before her reputation recovered from the scandal of her private life—she had a child while unmarried, and attempted suicide more than once. Wollstonecraft was the mother of Frankenstein author Mary Shelley.

ABOUT THE AUTHOR OF THE ANALYSIS

Dr Ruth Scobie holds a PhD in English literature from the University of York. She is currently an Early Career Research Fellow at TORCH at the University of Oxford, where she specialises in the eighteenth century and the development of celebrity.

ABOUT MACAT

GREAT WORKS FOR CRITICAL THINKING

Macat is focused on making the ideas of the world's great thinkers accessible and comprehensible to everybody, everywhere, in ways that promote the development of enhanced critical thinking skills.

It works with leading academics from the world's top universities to produce new analyses that focus on the ideas and the impact of the most influential works ever written across a wide variety of academic disciplines. Each of the works that sit at the heart of its growing library is an enduring example of great thinking. But by setting them in context – and looking at the influences that shaped their authors, as well as the responses they provoked – Macat encourages readers to look at these classics and game-changers with fresh eyes. Readers learn to think, engage and challenge their ideas, rather than simply accepting them.

'Macat offers an amazing first-of-its-kind tool for interdisciplinary learning and research. Its focus on works that transformed their disciplines and its rigorous approach, drawing on the world's leading experts and educational institutions, opens up a world-class education to anyone.'

Andreas Schleicher
Director for Education and Skills, Organisation for Economic Co-operation and Development

'Macat is taking on some of the major challenges in university education ... They have drawn together a strong team of active academics who are producing teaching materials that are novel in the breadth of their approach.'

Prof Lord Broers,
former Vice-Chancellor of the University of Cambridge

'The Macat vision is exceptionally exciting. It focuses upon new modes of learning which analyse and explain seminal texts which have profoundly influenced world thinking and so social and economic development. It promotes the kind of critical thinking which is essential for any society and economy.
This is the learning of the future.'

Rt Hon Charles Clarke, former UK Secretary of State for Education

'The Macat analyses provide immediate access to the critical conversation surrounding the books that have shaped their respective discipline, which will make them an invaluable resource to all of those, students and teachers, working in the field.'

Professor William Tronzo, University of California at San Diego

WAYS IN TO THE TEXT

KEY POINTS

- Mary Wollstonecraft (1759–97) was an English writer and philosopher whose landmark work *A Vindication of the Rights of Woman* was first published in 1792. Her struggles to live as an independent woman influenced her writings on education and equal rights.

- In *Rights of Woman*, Wollstonecraft argues that society's expectations of women teach them to be weak, helpless, and ignorant. She proposes that men and women are equally human, and so should receive similar educations to become rational* and independent.

- While not the first book to argue for better treatment for women, *Rights of Woman* was groundbreaking in its suggestion that apparently natural differences between male and female behavior could be the result of nurture, not nature.

Who Was Mary Wollstonecraft?

Mary Wollstonecraft, the author of *A Vindication of the Rights of Woman* (1792) was born in London in 1759. Her family was not rich, and she left home at 19 to work as a lady's companion* (someone paid to provide companionship and conversation to a woman of high status), a governess, and a teacher. In 1784 she tried to set up her own school.

Her personal experiences helped her to understand the difficulties that many women faced in eighteenth-century Britain. These women needed to earn a living but were not educated for, or allowed to do, most jobs. Wollstonecraft subsequently became a professional writer and translator, publishing fiction, stories for children, and books about education and politics.

Wollstonecraft was interested in the Revolution Controversy*—a public debate taking place in eighteenth-century Europe about the causes and principles of the French Revolution* (the uprising that had begun in France in 1789, resulting in the overthrow of the French monarchy and the introduction of radical new social and political systems). She was part of a group of liberal* writers, politicians, philosophers, and activists, who were inspired by aspects of this revolutionary thinking and who argued that all humans had natural rights* (roughly, fundamental freedoms) that should be protected by governments. "Liberal" here refers to the belief that the government should be changed to create a more equal, freer society.

While the revolution in France inspired these British liberals, however, it alarmed many British conservatives,* who feared there might be a similar radical* uprising in Britain ("radical" thinkers believe that wholesale change to the system is required to address social problems such as inequality). As a result, liberal writers like Wollstonecraft faced criticism and censorship in the 1790s.

Attacks on Wollstonecraft were especially fierce, partly because many people disapproved of women writing about politics. Her private life was also turbulent and controversial: she travelled widely and independently, had a child while unmarried, and attempted suicide more than once. After she died in 1797, her husband, the radical political philosopher William Godwin,* published a memoir* of her life. This caused a scandal and for many years the controversial story of her life affected the reception of her work, especially her arguments about women and their place in society.

What Does *A Vindication of the Rights of Woman* Say?

In *Rights of Woman*, Wollstonecraft argues that many of the differences between men and women are not the result of their biology or spiritual natures, but of their education and upbringing. Since men and women both have souls* (for Wollstonecraft, the spirit or basic moral humanity of a person, which lives on after that person dies), both are able to think, act, and become virtuous* in a rational way. By "rational," Wollstonecraft means using the ability to base actions on logic and experience, rather than belief or tradition. Society, she suggests, should teach girls as well as boys to become independent, rational adults.

Today this argument forms the basis of the Western political and philosophical movement that we now call feminism.* Feminism argues, broadly, that men and women should be treated equally, but that traditional conventions and beliefs often put women at a disadvantage. In particular, feminism usually opposes the idea that nature gives men and women different bodies, and so naturally opposing characters* and purposes in life. It points out that this idea, now sometimes called "gender essentialism,*" is often an excuse to deny women the same rights and freedoms as men. *Rights of Woman* was one of the first books to lay out these principles, and to challenge the idea of gender essentialism. It gave later writers a model of how they could analyze women's place in society. Wollstonecraft suggests that even traditions and beliefs that appear to protect or flatter women (the idea that women are more caring than men, for example) might actually be part of broader systems preventing women from gaining full equality.

After its publication in England in 1792, *Rights of Woman* was also published in Germany, France, and America. Countless new editions of the book were printed throughout the nineteenth and twentieth centuries, and it influenced other female writers, such as the novelist and essayist Virginia Woolf.* For more than a century, the scandal of

Wollstonecraft's private life made many readers reluctant to acknowledge the importance of *Rights of Woman*, but since the 1970s it has been recognized as a central feminist text, an important historical document, and a classic work of literature. It is available in many academic and popular editions, included in university syllabuses on history, literature, philosophy, and education, and analyzed in thousands of scholarly articles and books. Wollstonecraft's life and works have also been the subject of many documentaries, biographies, and novels.

Although feminism has gone through many changes and now takes many different forms, feminist campaigns based on the basic principles first introduced in *Rights of Woman* have transformed Western society. These controversial principles remain important in many academic and political debates today, from questions about the kind of toys parents should give their daughters and sons, to discussions about female leadership or equal pay.

Why Does *A Vindication of the Rights of Woman* Matter?

Rights of Woman sets out the basic principles of feminist thought in a simple and direct way. These principles laid the foundations for a political and intellectual movement that has transformed almost every aspect of modern life, and which remains influential and controversial all over the world. All the key ideas and arguments that would be developed by later feminist activists and thinkers are contained in some form in *Rights of Woman*. So, as a historical document, it shows how the broad movement of feminism grew out of a particular time and place, in response to the culture and problems of middle-class women in eighteenth-century Britain.

Wollstonecraft's book also summarizes many of the key theories of the French Revolution and the Enlightenment*—the European intellectual movement emphasizing the notion that ideas and behavior should be based on experience, science, and logic, not on tradition and authority. Reading *Rights of Woman*, then, is a good way to become

familiar with the concepts that shaped a crucial period in Western intellectual history. For students of modern politics and theory, the book illustrates some of the historical roots of revolution, and shows how they are linked to other movements and problems. Finally, because it has inspired or provoked a great deal of writers and thinkers since its publication in 1792, *Rights of Woman* provides an important context for many literary works, especially those by female authors.

Beyond this, Wollstonecraft's book provides a master class in persuasive writing and cultural analysis—two skills vital to any student of the humanities. It explains how an intellectual theory, the idea of human reason,* can lead logically to other radical ideas, such as the belief that men and women have equal rights. Then, in turn, it suggests how these ideas could translate into real actions. It argues in detail that these actions would benefit everyone in society. Wollstonecraft knew that her conclusions would seem ridiculous to many readers, so she supports every point with clear argument and evidence. She examines and analyzes the writings of other authors, showing where she thinks they have made mistakes. And she challenges concepts that her readers took for granted, such as "character" or "modesty." This encourages her readers to think critically rather than to rely on tradition or authority. In this way, *Rights of Woman* is a model example of one of Wollstonecraft's key ideals—that everyone should think for themselves.

SECTION 1
INFLUENCES

MODULE 1
THE AUTHOR AND THE HISTORICAL CONTEXT

KEY POINTS

- *A Vindication of the Rights of Woman* was the first book to outline the principles of a feminist* theory of society and education.*
- Mary Wollstonecraft's turbulent and unconventional life formed her views, but overshadowed her work for many years.
- Wollstonecraft's arguments developed because she moved in radical* political circles (among people who believed that revolutionary political change was required if things such as greater equality were to be achieved) and was in contact with people involved in the French Revolution (1789–99).* The intellectual principles of these groups encouraged her to challenge accepted eighteenth-century views about the nature and appropriate behavior of women.

Why Read This Text?

A Vindication of the Rights of Woman provoked controversy when it was first published in 1792. But in writing it, the eighteenth-century philosopher Mary Wollstonecraft laid out the foundations of modern feminist theory—and her arguments continue to inspire and provoke debate today.

In *Rights of Woman*, Wollstonecraft makes a passionate case for the equal rights of men and women to the freedom and education they need to live rational* and independent lives. While acknowledging the

> ❝ This will be the story of an independent and compassionate woman, who devised a blueprint for human change, held to it through the Terror* and private trials, and passed it on to her daughters and future generations. ❞
>
> Lyndall Gordon, *Vindication: A Life of Mary Wollstonecraft*

different characters,* qualities, and abilities that men and women appear to possess, she challenges the assumption of the time that these things can be explained by differing biological and spiritual purposes in life. For Wollstonecraft, the ultimate purpose of life is to follow our reason* and our sense of virtue* (that is, the ability to act in a morally good way); so both women and men, she argues, need to be properly educated. For Wollstonecraft, by failing to educate equally, British society condemned many women to grow up weak, foolish, and dependent on men, who often treated them badly.

Perhaps Wollstonecraft's most groundbreaking argument is that many of the apparently natural qualities and failings of people—especially, but not only, women—are in fact caused by their upbringing. She gives many examples of how society first imposes false rules and expectations on girls about how women should behave, and then punishes them for following these same rules. For instance, girls were taught to think only about their appearance, but then women were accused of being shallow and ignorant. More than two hundred years later, Wollstonecraft's outraged but logically argued analysis of this process continues to provide a model for feminist and other political forms of analysis and argument.

Author's Life

Mary Wollstonecraft was born in London in 1759. She endured a

difficult and chaotic childhood in a British middle-class family that had lost most of its money before she was a teenager. The failure of her alcoholic father to provide for her, and the experience of being neglected by both parents in favor of her brother, convinced the young Wollstonecraft that the idea that women should be passive and dependent on men was unfair.

Educating herself by reading widely, Wollstonecraft left home at 19 and struggled to earn a living in some of the few jobs that were open to women like her in eighteenth-century Britain—she worked as a lady's companion* (a paid companion to a woman of status or wealth, offering good conversation and company), a children's governess, and a teacher. However, in 1786 she was employed by the London publisher Joseph Johnson.* A supporter of radical political causes, Johnson introduced her to other well-known radical figures, such as the poet and artist William Blake,* and the political journalist and revolutionary Thomas Paine.* Johnson also employed her as a translator, editor, reviewer, and author, a job that gave her the opportunity to read and write about many different topics. Working for Johnson allowed Wollstonecraft to develop her knowledge of politics and philosophy.

Johnson's circle, including Wollstonecraft, supported the principles of the French Revolution, the uprising that had begun in 1789 in which the French king was overthrown and executed, and radical new social and political systems were introduced. Few of the male political radicals Wollstonecraft knew in France or Britain, however, were interested in giving equal rights to women, and some even dismissed Wollstonecraft's work on the basis that women should not take part in politics. Published in 1792, three years after the first French uprising, *Rights of Woman* can be seen in part as Wollstonecraft asserting her own right to think rationally about society and express her opinions in public.

Wollstonecraft's personal life was marked by passionate but unhappy relationships with friends and lovers, including the adventurer Gilbert Imlay,* with whom she lived and had a daughter while unmarried. Her affairs can be seen as attempts to put into practice her radical political principles of freedom and independence from social conventions. But in a conservative* society based on tradition and stability, these were also dangerous and provocative acts. Wollstonecraft's behavior influenced the way her work was received by later readers, who often thought of her as either a romantic or an immoral figure. She died in 1797, after giving birth to her second daughter, Mary,* who would grow up to marry the Romantic* poet and political radical Percy Bysshe Shelley* and write the famous novel *Frankenstein*. (Romanticism was a contemporary cultural and intellectual movement that stressed the value of nature, emotion, and freedom.)

Author's Background

In eighteenth-century Britain, women were, as Wollstonecraft notes, "treated as a kind of subordinate* beings."[1] Tradition, science, and religious teaching all presented them as weaker, less intelligent, more passive, and more emotional than men. It was believed that the role of women in this society was to have and to care for children, and to look after and serve men: their fathers, brothers, and husbands. Indeed, in the eyes of the law, married women, their children, and their property all legally belonged to their husbands.

Because women were expected to depend on a man, upper- and middle-class girls were usually only educated in the skills they needed to attract a good husband, such as dressing well, dancing, and making light conversation. Universities, and professions such as medicine or law, were only for men, while women with knowledge of academic subjects were often regarded as masculine and unnatural. It was also generally accepted that men could have sexual relationships outside

marriage, but any woman who had sex with a man other than her husband was regarded as ruined and so was excluded from society.

While most then believed that this was simply how things had to be, it was also recognized that there were women who suffered in this system. Many unmarried women, widows, or wives with bad or neglectful husbands could not rely on support from a man. But these women were also prevented from providing for themselves because of a lack of education or a lack of opportunities. The ideas of the Enlightenment*—the eighteenth-century philosophical movement that sought to challenge tradition and religion and introduce rational cultural innovations, emphasizing liberty and individualism—inspired Wollstonecraft to investigate these problems. In the atmosphere created by the French Revolution, which made radical changes actually seem possible, she was able to challenge the idea that the oppression of women by society was both natural and inevitable.

NOTES

1 Mary Wollstonecraft, *A Vindication of the Rights of Woman,* in *A Vindication of the Rights of Woman and A Vindication of the Rights of Men*, ed. Janet Todd (Oxford: Oxford University Press, 2008), 71.

MODULE 2
ACADEMIC CONTEXT

KEY POINTS

- Debate developed during the eighteenth century over whether societies should be governed by tradition and hierarchical* authority, where rule was based on a person's level or class, or by new ideas of the rights of rational* individuals to govern themselves.

- After the French Revolution* in 1789 and the overthrow of the French monarchy (a challenge to the inequality in the system that the monarchy personified), debate intensified and conservative* thinkers like the politician and essayist Edmund Burke* condemned the idea of using rights and reason* as the basis of government.

- Mary Wollstonecraft was a supporter of radical* politics, having written an earlier "Vindication" defending the principles of the French Revolution. She wrote *Rights of Woman* to extend these principles to the subject of women.

The Work in its Context

Mary Wollstonecraft's *A Vindication of the Rights of Woman* was a product of the European Enlightenment,* a period when writers began challenging the values of tradition and authority that had dominated earlier societies and cultures. Older forms of philosophy imagined human individuals as fixed types in unchanging social hierarchies, with characters,* lives, and roles set by the station God had given them. However, in the seventeenth century it was suggested by thinkers like the English philosopher John Locke* (one of the founders of the Enlightenment) that individuals were, instead, born as

> ❝ But there is another and great distinction for which no truly natural or religious reason can be assigned, and that is the distinction of men into KINGS and SUBJECTS. Male and female are the distinctions of nature, good and bad the distinctions of Heaven; but how a race of men came into the world so exalted above the rest, and distinguished like some new species, is worth inquiring into, and whether they are the means of happiness or of misery to mankind. ❞
> Thomas Paine, *Rights of Man*

"blank slates" and were shaped by their experiences and environment.

Other theorists argued that if this was the case, then any person with the ability to think and reason had both the potential and the right to improve their knowledge and understanding. To do this people should not rely on authority figures such as priests, but should read, experiment, and think for themselves. Some writers saw this in terms of a grand historical process of civilization. Others, such as the Dissenting Christians* (British followers of the Protestant* branch of Christianity who disagreed with the established state Church, and with whom Wollstonecraft sympathized), believed that using individual reason was a spiritual duty. In fact, they regarded it as the only way to get closer to God and understand how to be virtuous.*

Political theorists such as Thomas Paine* translated these philosophical ideas into doctrines of revolutionary change in the eighteenth century. They argued that fixed political hierarchies like that of the French monarchy prevented people from exercising their natural right to reason and freedom. By the time Wollstonecraft wrote *A Vindication of the Rights of Woman*, these arguments had been put into practice in the creation of new, "democratic" forms of government in

America, and then in France. In a less dramatic fashion, many people in Britain imagined and experimented with new ways of living, new kinds of relationships, and new methods of education* based on individual reason.

Overview of the Field

Rights of Woman was published in 1792 as a contribution to the fierce debate (sometimes called the Revolution Controversy)* that raged in Britain over the ideals and impact of the French Revolution. In 1790, the politician Edmund Burke published his *Reflections on the Revolution in France*. This was a powerful and influential attack on the revolutionary "spirit of innovation,"*[1] which he regarded as not only dangerous to the stability and morality of France, but also England, where he and many others feared another revolution. Burke argued that rights and property should be inherited, and that to work harmoniously societies need the stability and continuity provided by tradition. He believed that sudden radical changes based on abstract theories were likely to fail because people who no longer knew their place and purpose in life would be unhappy and violent.

Among the pamphlets that opposed Burke were Wollstonecraft's own *Vindication of the Rights of Man* (1790) and Paine's *Rights of Man* (1791). These criticized Burke's idealization of prejudice as irrational and drew attention to his dismissal of the suffering of the people at the bottom of the social hierarchy. In contrast, they imagined a utopian* (imaginary ideal) society in which rational individuals would be free to work for their own improvement. Wollstonecraft's later *Rights of Woman* was a further contribution to the pro-revolutionary argument against Burke, building on her earlier *Vindication of the Rights of Man*. More unusually, it was also an attempt to add the issue of women's place in society to these revolutionary theories of reason and natural rights* (the rights we are entitled to because we are alive).

Academic Influences

Wollstonecraft was influenced by Richard Price,* a radical political writer and Dissenting minister.* She attended services at his church and he became a friend and mentor. She describes him in *Rights of Woman*, which was published shortly after his death, as "one of the best of men."[2] Price introduced Wollstonecraft to the wider Dissenting and politically radical circle around the London publisher Joseph Johnson.* The political and philosophical ideas of this circle, and their values of open debate and radical innovation, shaped Wollstonecraft's thinking in the 1790s. By employing her to write book reviews, Johnson also helped provide her with the skills and confidence to write bold, analytical commentaries on the works of respected male writers such as Burke and the French philosopher Jean-Jacques Rousseau.* Wollstonecraft was infuriated by Rousseau's opinion that women should be educated only to serve men and this provoked her to write *Rights of Woman*.

The book was written partly in the tradition of political polemic,* a style intended to persuade readers of a political position through logical argument, evidence, and emotive rhetoric. However, this approach was combined with both the genre of the conduct book* (a practical guide to social life and behavior) and the educational treatise.* In writing a guide to education, Wollstonecraft was deliberately imitating the writing of Rousseau, whose ideas about general education in Émile (1762) she admired, but whose exclusion of women she wished to correct.

NOTES

1 Edmund Burke, *Reflections on the Revolution in France*, ed. Leslie Mitchell (Oxford: Oxford World's Classics, 1999), 33.

2 Mary Wollstonecraft, *A Vindication of the Rights of Woman*, in *A Vindication of the Rights of Woman and A Vindication of the Rights of Men*, ed. Janet Todd (Oxford: Oxford University Press, 2008), 81.

MODULE 3
THE PROBLEM

KEY POINTS

- Mary Wollstonecraft is interested in the question of how rationally* to define the role of women in a free and enlightened society, where behavior should be based on logic rather than on tradition.

- Like the conservative* writers of British conduct books* (a popular genre aimed at advising readers how to behave), most of the radical* writers Wollstonecraft admired seemed to exclude women from their definition of a rational individual, and so deny them the same rights as men.

- In *Rights of Woman*, Wollstonecraft uses the principles of Enlightenment* reason* to argue that progressive philosophers and conservative commentators alike were wrong to deny women freedom, education,* and a political voice.

Core Question

Mary Wollstonecraft's starting point in *A Vindication of the Rights of Woman* is the belief that the best way to run a society is to encourage individuals to use and develop their reason (that is, their capacity to decide and reflect according to logic and experience rather than tradition or emotion). She shares this belief with other Enlightenment and French Revolutionary* thinkers, who argue this approach is necessary both for the progress of the society as a whole and for the personal fulfillment and virtue* of each individual. The innovation of *Rights of Woman* is its detailed exploration of how women might fit into such a society founded on reason, in the face of the widespread assumption that they should not use and develop their own minds, but

> **" Who made man the exclusive judge, if woman partake with him the gift of reason? "**
>
> Mary Wollstonecraft, *A Vindication of the Rights of Woman*

obey and agree with men.

Wollstonecraft argues that women do have *some* capacity to reason, even if she seems to see that capacity as less than that of men. In support of this premise, she gives examples of academically accomplished women. Her best example is, implicitly, herself, as an articulate and rational writer arguing against the most famous male academics in the world. More fundamentally, she refers to the Enlightenment philosophical definition of a human as a being who has reason. To exclude women from the use of reason, she points out, would logically exclude them from humanity—yet female humans are still agreed to be human. If they were not, how could they act as good wives or effectively educate their sons?

Wollstonecraft believes that the purpose of any person with a soul* is to use reason to pursue virtue. Without reason, a person would only be able to act instinctively, like an animal: virtue would be impossible, since good could only be done by accident. If women entirely lacked reason, Wollstonecraft argues, they would also lack souls and would therefore be excluded from heaven after death. This is a conclusion that contradicts the Christian doctrines she assumes her readers will share.

But if women *do* have reason, Wollstonecraft asks, why should they be prevented from exercising this reason freely? Repeating this central problem several times, she goes on to explore the ways that women's use of reason is restricted by social conventions, expectations, and especially methods of education. She also imagines how this could be changed to allow women to act as rational humans.

The Participants

Wollstonecraft had been inspired by the advice of Enlightenment and revolutionary philosophers to think for herself and to question authority. But she found those same philosophers excluded her, as a woman, from their "universal"* concepts of human nature and reason. For example, the radical philosopher Thomas Paine* argued that all men have the same rights because they have the same capacity to reason; but added that the differences between "Male and female are the distinctions of nature."[1]

This was a long-running, but somewhat one-sided debate. A handful of earlier thinkers such as Mary Astell* had already questioned the logic of granting universal rights to men but not women, asking as early as 1700: "If all Men are born free, how is it that all Women are born Slaves?"[2] A few influential theorists of the French Revolution, most notably Olympe de Gouges* and Nicolas de Condorcet,* had recommended that women be granted full citizenship* (that is, given full political and legal rights) in the new French state. But readers ridiculed or ignored these views in both France and Britain. Women could not vote in Revolutionary France, and in 1791, immediately before Wollstonecraft began writing *Rights of Woman*, an official report to the French government by politician Charles Maurice de Talleyrand-Périgord* recommended that the new national program of education should prepare girls only for domesticity*—matters pertaining to the home—and motherhood.

Talleyrand was following the influential arguments of the French philosopher Jean-Jacques Rousseau's* treatise* *Émile* (1762), which laid out a plan of education encouraging the natural use of reason. This, Rousseau claimed, was only appropriate for boys, since girls had essentially different minds and so essentially different roles in life: they could not be rational and virtuous in the same way as a man, and so a "woman's education" should teach her "to make his life pleasant and happy."[3] Although other parts of Rousseau's book were widely

regarded as shocking, these views on women were shared by most conservative British commentators, like the clergyman James Fordyce* in his popular *Sermons to Young Women* (1766).

The Contemporary Debate

Rights of Woman can be understood as a conversation with Rousseau, who is quoted critically at length. Although Wollstonecraft is scathing about his program of education for girls, the development of her thought was also positively shaped by his work. Indeed, privately she wrote that she had "always been half in love with" Rousseau.[4] It was therefore important to Wollstonecraft that she demonstrate that his opinions on female education were not only wrong, but also inconsistent with his main principles and concepts.

Wollstonecraft also cites and critiques many other theories of gender, especially from the conduct books that she saw as discouraging girls from developing reason and virtue. She also quotes some writers, such as the English philosopher John Locke,* in support of her points. But the citation of earlier authorities is not a central element of *Rights of Woman*, partly because its argument is so original that Wollstonecraft has few writers to choose from, and partly because of her Enlightenment belief that readers should be convinced by logical argument rather than faith in authority.

Wollstonecraft, of course, was at a disadvantage in this debate, since the supporters of writers like Rousseau rejected not only her arguments, but also her right, as a woman, to make a political argument and be taken seriously.

NOTES

1 Thomas Paine, *Rights of Man*, in *Rights of Man, Common Sense, and Other Political Writings*, ed. Mark Philp (Oxford: Oxford World's Classics, 2008), 7.

2 Mary Astell, *Reflections upon Marriage*, in *Astell: Political Writings*, ed. Patricia Springborg (Cambridge: Cambridge University Press, 1996), 18.

3 Jean-Jacques Rousseau, *Émile; or On Education*, ed. P. D. Jimack, trans. Barbara Foxley (London: Everyman, 2000), 393.

4 Mary Wollstonecraft, letter to Gilbert Imlay (Paris, September 22, 1794), in *The Collected Letters*, ed. Janet Todd (London: Penguin, 2003), 263.

MODULE 4
THE AUTHOR'S CONTRIBUTION

KEY POINTS

- Mary Wollstonecraft argues that the role of a woman in an enlightened, progressive* society is essentially the same as the role of a man, requiring the same virtues* and the same principles of education.*

- *Rights of Woman* combines the radical* ideas of natural rights,* reason,* and personhood* (the status or quality of being a human individual) with the early feminist* arguments of writers like Catharine Macaulay.* In doing so, Wollstonecraft creates an inspiring but incomplete theoretical polemic* (a piece of writing that persuasively and directly attacks an opinion or theory) in support of her recommendations for national education.

- In *Rights of Woman*, Wollstonecraft relied heavily on earlier work by Catharine Macaulay and others, but expressed it in a bolder and more developed way.

Author's Aims

In *A Vindication of the Rights of Woman*, Mary Wollstonecraft aimed to set out, and justify, a plan for a national program of education that would include both boys and girls, based on the principles of reason and freedom. In arguing that a new, enlightened program of education is needed to reform women's personal progress and make possible a new and better society, Wollstonecraft appears to be following the lead of the French philosopher Jean-Jacques Rousseau* and other writers on female education, as well as the new French state with its creation of Revolutionary public schools in the 1790s. These, however, had

> ❝ Contending for the rights of woman, my main argument is built on this simple principle, that if she be not prepared by education to become the companion of man, she will stop the progress of knowledge and virtue; for truth must be common to all. ❞
>
> Mary Wollstonecraft, *A Vindication of the Rights of Woman*

attempted to define the best way to teach women to fulfill a uniquely female role with uniquely female virtues; in contrast, Wollstonecraft argues that the most important roles and virtues of men and women are fundamentally the same. She sets out to prove that virtues are not inherently "sexual"—that is, that the value and quality of a virtue does not depend on whether the person practicing it is male or female.

Rights of Woman was written very quickly, and Wollstonecraft planned to add further sections, "to elucidate some of the sentiments, and complete many of the sketches," but never did.[1] So while the book is regarded as successful as an inspiring polemic, it did not live up to Wollstonecraft's aims as a detailed and coherent thesis.

Approach

Wollstonecraft unpicks earlier thinking on female education and manners* by investigating the philosophical and theological* concepts that were used to support them (theology is the systematic study of religious ideas, commonly through the analysis of scripture). This was an original approach, presenting the radically new idea that the perfect moral and intellectual education could be essentially the same for both boys and girls.

She argues that all children should be encouraged to develop their reason and should be left as free and unsupervised as possible while being given access to books and ideas that suit their individual abilities.

Wollstonecraft also condemns parents and teachers who force children to submit blindly to authority with memorization learning (learning by rote, or repetition). She argues that this teaches them to be dependent, and encourages them to be cunning to get their way. And in contrast to writers like Rousseau, she sees the forced subordination* of girls and women to the authority of their fathers, brothers and husbands to be just as damaging.

Wollstonecraft's work also departed from earlier feminist works in its concern for middle-class women who needed to achieve economic as well as intellectual independence. This leads her to discuss not only the forms of education suitable for leisured, aristocratic ladies, but the potential of women to work in business or politics, or "be physicians as well as nurses."[2] This was a radical suggestion, since these professions were reserved for men at the time.

Wollstonecraft places more emphasis, though, on her argument that women educated to be rational, independent, and virtuous will be better wives and mothers than women who have only been taught to be attractive. In this, she seems to concede the view of Rousseau—and the consensus of eighteenth-century society in general—that the main place for women is in the home. Crucially, however, she asserts that we also need to consider those women who, for whatever reason, cannot rely upon good husbands.

Contribution in Context

While Wollstonecraft's basic concepts are mostly borrowed from her readings of Enlightenment* and radical political philosophers such as Rousseau and Thomas Paine,* her more specific opinions on the place of women can be linked to earlier female authors who complained about the injustices and restrictions of women's lives, and opposed persistent accusations that women were naturally sinful, weak, and stupid. In the seventeenth century the poet Anne Finch,* for example, had lamented women's "fallen" state, calling women

"education's, more than nature's fools."[3] Yet, with the exception of Mary Astell,* who based her arguments on Christian theology, very few of these writers produced detailed, developed works of theory, and their influence was usually limited to the small aristocratic circles in which the writers themselves lived. Furthermore, because they were women, their work was often ignored or not taken seriously.

More directly, Wollstonecraft draws ideas from the historian Catharine Macaulay's *Letters on Education* (1790). In this treatise* on the theory of education, Macaulay argues that women are naturally moral and rational beings, not "the mere objects of sense"[4] (that is, not just animals following their instincts). She also suggests that many of the apparent weaknesses of women are caused by their environment, not nature. Wollstonecraft reviewed this book enthusiastically in 1790, and refers to Macaulay in *Rights of Woman* as: "The woman of the greatest abilities, undoubtedly, that this country has ever produced."[5] One biographer describes Wollstonecraft's reading of *Letters on Education* as the "turning point" in the development of her feminism.*[6] But even in her review, Wollstonecraft notes that Macaulay's ideas "might have been carried much farther" in a work that gave more space to the principles and implications of female education.[7]

Rights of Woman, then, can be seen as Wollstonecraft's attempt to extend, develop, and promote Macaulay's ideas in the light of her own thinking about Enlightenment concepts of reason, progress, and natural rights.

NOTES

1 Mary Wollstonecraft, *A Vindication of the Rights of Woman*, in *A Vindication of the Rights of Woman and A Vindication of the Rights of Men*, ed. Janet Todd (Oxford: Oxford University Press, 2008), 69.

2 Wollstonecraft, *Rights of Woman*, 229.

3 Anne Finch, "The Introduction," in *Major Women Writers of Seventeenth-Century England*, ed. James Fitzmaurice et al. (Ann Arbor: University of Michigan Press, 2005), 335–37, l. 52.

4 Catharine Macaulay, *Letters on Education: With Observations on Religious and Metaphysical Subjects*, Cambridge Library Collection reissue (Cambridge: Cambridge University Press, 2014), 62.

5 Mary Wollstonecraft, *Rights of Woman*, 180.

6 Gary Kelly, *Revolutionary Feminism: The Mind and Career of Mary Wollstonecraft* (New York: St Martin's Press, 1992), 83.

7 Mary Wollstonecraft, "Review of Catharine Macaulay, *Letters on Education*," in *Analytical Review* 8 (1790): 250.

SECTION 2
IDEAS

MODULE 5
MAIN IDEAS

KEY POINTS

- *Rights of Woman* primarily explores how best to educate*
 and treat women in an enlightened society.

- Mary Wollstonecraft argues that society should enable
 women to use their own "moral reason"*—the ability to
 use logic to decide if an action is right or wrong—in the
 same way as men. They should not be forced into moral and
 intellectual dependence on men.

- *Rights of Woman* is a polemic*—an attack on an opinion or
 theory, intended to persuade readers of the writer's point of
 view. It uses step-by-step logic to convince the reader of its
 arguments, but also to convince them that Wollstonecraft is
 herself a "rational* creature."

Key Themes

Mary Wollstonecraft's *A Vindication of the Rights of Woman* argues that
an enlightened Christian society must recognize the essential
humanity and rights of women. For Wollstonecraft, this conclusion
follows logically from the acceptance of two much-discussed
concepts:

- The Enlightenment* definition of virtue* as the pursuit of good
 based on the free use of reason.
- That an individual's character* is not fixed, but is, rather, shaped by
 environment and education–the product of nurture as well as nature.

Wollstonecraft makes the groundbreaking, and at the time
contentious, assertion that since moral reason is the one and only

> **❝** It is time to effect a revolution in female manners—time to restore to them their lost dignity—and make them, as part of the human species, labour by reforming themselves to reform the world. **❞**
>
> Mary Wollstonecraft, *Vindication of the Rights of Woman*

route to virtue, this moral reason *must* be available to all humans, both male and female. Against the common claim that women's characters and roles are so different to men's that they clearly have different virtues, Wollstonecraft offers the radical view that these differences are mostly either artificial or imaginary. Even if there are differences between the bodies of men and women, these differences are of minor significance, and do not naturally lead to what were seen as stereotypically* feminine* personality traits, such as passivity, cunning, or attention to dress and gossip. Instead, Wollstonecraft explains, these are "consequences of [women's] education and station in society."[2]

Rights of Woman links these ideas about personal behavior and virtue to its wider theme of government and the best means of creating a new, rationally ordered society. Wollstonecraft believes that the free use of reason is the best way to govern a society, at all levels. People who are forced to subordinate* their reason to the will of an authority—whether a monarchy, a teacher, or a husband—cannot develop and practice moral reason. So when social structures or education systems prevent women from exercising their reason freely (for example, if wives are taught to obey their husbands blindly), then women cannot be truly virtuous, for the same reason that animals and children cannot be truly virtuous. Not only do these restrictions harm women, Wollstonecraft adds, but they also damage society as a whole, because a woman lacking reason, knowledge, and virtue is unlikely to succeed in fulfilling her social roles as wife and mother.

Exploring the Ideas

Presenting her core argument as a complete theory from the start, Wollstonecraft repeatedly returns to these central themes and arguments in a series of chapters that expand on specific details or implications. To begin with, she announces her intention "to go back to first principles in search of the most simple truths, and to dispute with ... prevailing prejudice every inch of ground."[3] In other words, she expects her arguments will challenge many of the reader's assumptions, and that these beliefs will have to be broken down before she can make her case. The first chapter, therefore, offers a summary of the important background idea of moral reason and freedom.

Moving on to a lengthy examination of "prevailing prejudice" about women's natural capacity for moral reason, Wollstonecraft offers a point-by-point rejection of the advice given by the French philosopher Jean-Jacques Rousseau* and British writers on education that girls should aim to become mindlessly "feminine." She does this not only to argue against their theoretical opposition to her own ideas, but also to give examples of precisely the sort of prejudiced expectations she believes shape women's upbringings. These particular upbringings, therefore, produce the characteristics that people like Rousseau then claim are natural. As an example, Wollstonecraft notes that Rousseau and similar writers such as the Scottish minister James Fordyce* claim little girls are usually drawn to clothes and looking pretty. Rousseau and Fordyce suggest this is evidence that women are naturally predisposed to care about their appearance—and, as a consequence, their education should respect and encourage this, focusing on dress, needlework, and grace.

Wollstonecraft points out, however, that this kind of advice will actually produce the very behavior it describes. If parents, teachers, and girls themselves are told this is both natural and normal behavior, and if a little girl is praised for thinking about her appearance, then she will start to care about clothes. But this is not an innate characteristic.

The book then goes on to explore a series of supporting ideas, restating its central argument in the light of each one:
- the effect of early education and environment on the mind
- modesty and the relationship between emotion and virtue
- the moral consequences of oppressive social structures
- the rights and responsibilities of parents and children
- Wollstonecraft's plan for national education.

Language and Expression

As *Rights of Woman* is a polemic, Wollstonecraft aims to persuade readers of the validity of her conclusions through the sheer force of her argument. Her criticisms of other writers can be scathing, because she especially wants to anticipate and refute the objections of her opponents. Alongside a series of dramatic and emotive metaphors, such as her repeated comparisons between women and slaves, this reflects and provokes a strong sense of Wollstonecraft's moral indignation.

Wollstonecraft was aware, though, that by using emotional language, she risked undermining a key claim: that women are capable of reason. Even readers who agree with Wollstonecraft's idea that true knowledge can only be reached through the free use of reason might see her use of passionate rhetorical tricks, like metaphor, as manipulative or coercive. Therefore she balances these tricks carefully with a calm, logical tone that returns repeatedly to basic principles to demonstrate its logic. This reflects not only Wollstonecraft's ideas about moral reason, but also her need as a female writer to disprove the claims made by her opponents that women are unable to understand abstract ideas or political principles. She also consciously rejects the "pretty feminine phrases"[4] that her contemporary readers might expect a woman to use. These, she argues, are misleading, because they make irrationality and immorality attractive.

NOTES

1 Mary Wollstonecraft, *A Vindication of the Rights of Woman*, in *A Vindication of the Rights of Woman and A Vindication of the Rights of Men*, ed. Janet Todd (Oxford: Oxford University Press, 2008), 73.

2 Wollstonecraft, *Rights of Woman*, 283.

3 Wollstonecraft, *Rights of Woman*, 76.

4 Wollstonecraft, *Rights of Woman*, 73.

MODULE 6
SECONDARY IDEAS

KEY POINTS

- In addition to the main argument presented in *Rights of Woman*, Mary Wollstonecraft also offers a range of practical suggestions for the reform of education,* manners* (for Wollstonecraft and her contemporaries, the ways that a person acts and treats others), and family life.

- For many readers, it was Wollstonecraft's secondary suggestions in *Rights of Woman* that indicated the radical* nature of her ideas.

- Wollstonecraft's vision of an education system based on nature and moral reason* rather than on fear and confinement, had some impact on Romantic* ideas of childhood, reinforcing the influence of Jean-Jacques Rousseau* in this field. Romanticism was a cultural and intellectual movement that stressed the value of nature, emotion, and freedom.

Other Ideas

In *A Vindication of the Rights of Woman*, Mary Wollstonecraft identifies a number of social problems that she believes are the results of poor education, both of girls and boys (by "education" she means all childhood treatment, not just formal teaching). To solve these problems, she offers a series of ideas for the reform of teaching practices, parenting, and manners. These are based in part on the arguments the French philosopher Jean-Jacques Rousseau offered in the first four books of his treatise on education, Émile, and on Wollstonecraft's own observations during her time working as a teacher and governess.

> **❝** I have turned over various books written on the subject of education,* and patiently observed the conduct of parents and the management of schools; but what has been the result?—a profound conviction that the neglected education of my fellow-creatures is the grand source of the misery I deplore. **❞**
>
> Mary Wollstonecraft, *A Vindication of the Rights of Woman*

She argues that national primary education* (the first stage of schooling in Britain) should be made available to all children, in the same day schools and wearing the same uniform, to discourage prejudice based on class. The wealthiest and the most talented poor students would go on to receive further academic education, while the rest would be trained in trades and professions (a program inspired by those being proposed in France in the 1790s). Even in Revolutionary France, however, the idea of educating boys and girls together was not taken seriously.

While Wollstonecraft's aim is what she calls "a REVOLUTION in female manners,"[1] she also wants to reform the behavior of men, especially those in the middle classes. Like much more conservative* contemporary writers, such as the English author Hannah More*—a woman hostile to the French Revolution*—Wollstonecraft disapproved of men who drank too much, gambled, or womanized, and of women that flirt, are vain, or who neglect their children. For Wollstonecraft, these moral failings are the consequence of education that focuses too much on gender differences, making children aware of sex and sexual difference too early in their lives. More radically, she also believed that children should only respect and obey their parents when this is compatible with their own moral reason (that is, by using logic to decide between right or wrong).

41

She predicts that if her reforms "make women rational* creatures, and free citizens* ... they will quickly become good wives, and mothers." Rational women will be able to make better moral choices, so their individual behavior and family relationships will improve.[2]

Exploring the Ideas

Wollstonecraft's ideas for educational reform offer practical examples of the implications of her main argument. To a reader in the eighteenth century, they would also have indicated the radical nature of the argument presented in *Rights of Woman*, since the program she suggested was different to the mainstream idea of a good education at this time.

Wollstonecraft condemned "careless and unnatural" parents who leave the upbringing of their children to nurses, servants, tutors, and governesses, or those who spoil children.[3] She disapproved of single-sex boarding schools, arguing that their "wearisome confinement" of children causes bad health and "pitiful cunning" in girls, and "nasty indecent tricks" and "habitual cruelty" in boys.[4] Instead, she proposed the establishment of national mixed-sex day schools. Children who live at home, she writes, develop a greater attachment to family life, and by growing up with friends of both sexes, will be better prepared to be an equal companion to their husband or wife.

Wollstonecraft also contended that children should not have to memorize and repeat information in a "parrot-like prattle"[5]—one of the most common teaching methods of her time. She imagined a system in which students were provided with the basic principles of moral reason and given the freedom to learn and develop as rational, thoughtful adults. They should spend as much time as possible outdoors and unsupervised, to encourage independence and an appreciation of nature.

Writing in the era of the French Revolution, Wollstonecraft did not want to be regarded as merely a theorist but as a revolutionary

whose ideas have the potential to drastically reform society for the better. By giving concrete suggestions, based on what she regarded as her own moral reason, she sought to demonstrate the power of Enlightenment* rationality to improve social structures. For this reason, each of her ideas for the reform of manners and education are justified by analysis of an existing problem, and reference to the broad concepts and arguments of the book.

Overlooked

Wollstonecraft's ideas about educational reform were too radical to have much practical impact in her own lifetime. She claims in an introduction addressed to the French government leader Charles Maurice de Talleyrand-Périgord* that she only wanted "to set some investigations of this kind afloat in France"—that is, to start a debate about possible innovations* in education.[6]

For a long time even this modest aim seemed unrealistic. Her book was interpreted by most eighteenth-century readers as a work of philosophy rather than a practical guide. Indeed, after her death, her own daughters were not brought up using the systems that she had proposed in *Rights of Woman*.

Even in the twentieth century, the status of this book as one of the foundations of modern feminism* and perceptions of Wollstonecraft as an inspirational or scandalous figure tended to overshadow what seem like her more mundane ideas about child development and education. But Wollstonecraft's writings about childhood and the argument she made for free, natural forms of education did have some influence on later Romantic writers such as the poet William Wordsworth,* whose *The Prelude* (1799–1850) offered similar thoughts about the importance of nature and freedom to childhood development.

More recently, theorists of education have begun to pay attention to Wollstonecraft's work. She is, for example, mentioned increasingly

often in textbooks and reference books, such as her substantial entry in the 2014 *Encyclopedia of Educational Theory and Philosophy*.[7] Recent historical studies have also started to place Wollstonecraft's ideas about childhood at the center of interpretations of her work, and of the history of childhood and practices of education in nineteenth-century Britain.

NOTES

1 Mary Wollstonecraft, *A Vindication of the Rights of Woman*, in *A Vindication of the Rights of Woman and A Vindication of the Rights of Men*, ed. Janet Todd (Oxford: Oxford University Press, 2008), 281.

2 Wollstonecraft, *Rights of Woman*, 265.

3 Wollstonecraft, *Rights of Woman*, 233.

4 Wollstonecraft, *Rights of Woman*, 248–49, 258

5 Wollstonecraft, *Rights of Woman*, 247.

6 Wollstonecraft, *Rights of Woman*, 68.

7 "Mary Wollstonecraft" in *Encyclopedia of Educational Theory and Philosophy*, ed. D. C. Phillips (Los Angeles: Sage Publications, 2014), 855–57.

MODULE 7
ACHIEVEMENT

KEY POINTS

- Mary Wollstonecraft's main achievement was to articulate a basic principle of feminism*—that women are essentially, entirely human. She argues that society should be reformed to reflect this, thus confronting and defying prejudice.

- Wollstonecraft's bold, polemic* style, matched with her personal reputation for rebelling against convention, has been central to the positive impact that *Rights of Woman* has had on readers in some eras and societies.

- The rushed, unstructured, and incomplete nature of her argument, coupled with Wollstonecraft's controversial personal reputation, have served to limit the book's political effectiveness in other, more conservative* periods and societies.

Assessing the Argument

Mary Wollstonecraft wrote *A Vindication of the Rights of Woman* very quickly. In a letter, she described herself handing pages straight to the printer as she finished writing them. She acknowledged that she was "dissatisfied with [herself] for not having done justice to the subject."[1]

The rushed writing process, and the lack of time to research, revise, and edit the book, can certainly be seen as having led to weaknesses in expression and structure. The work is repetitive and often digressive, making it difficult for readers to follow the main threads of Wollstonecraft's thought, and it lacks evidence beyond her own observations and opinions. Even her husband, William Godwin,* would describe it after Wollstonecraft's death as "eminently deficient

> ❝ Would she had blotted a thousand' is a phrase that
> haunts the air as one reads [*Rights of Woman*] ... but
> on the other hand she hit the exact tone of righteous
> indignation that is still effective—indeed it has become
> the staple tone of much successful journalism. Her book
> is still read. ❞
>
> Claire Tomalin, *The Life and Death of Mary Wollstonecraft*

in method and arrangement."[2]

Furthermore, Wollstonecraft planned to publish a second volume
of *Rights of Woman*, which would look in more detail at "the laws
relative to women, and the consideration of their particular duties."[3]
This volume was never written, although some of her notes were
published after her death, under the title *Hints Chiefly Designed to have
been Incorporated in the Second Part of the Vindication of the Rights of Woman*
(1798).[4] These indicate a number of other major themes that
Wollstonecraft wanted to consider. As a result, we could see the
argument of *Rights of Woman* as incomplete: in her own words, it is
"only the first part" of the book she intended to write.[5]

Nevertheless, as a convincing and moving polemic, *Rights of
Woman* articulates Wollstonecraft's belief in the fundamental humanity
of women. As Godwin notes, the book "forms an epocha [a new era]
in the subject to which it belongs."[6] The force of its original ideas and
language continue to impress and inspire readers today, providing
implicit evidence of women's capacity to reason* in the form of
Wollstonecraft herself.

Achievement in Context

Wollstonecraft had initially published her earlier *Vindication of the
Rights of Men* anonymously, but *Rights of Woman* appeared under her

own name. This meant that her readers knew that they were reading a book by a female writer. For many who believed that women could not understand abstract philosophical concepts and should not give their opinions in public, this immediately biased them against its arguments. "Politics," one writer warned Wollstonecraft, "are *unfeminine*."[7]

Moreover, Wollstonecraft openly supported the French Revolution,* and used vocabulary and ideas associated with revolutionary philosophy. The title, *Vindication of the Rights of Woman*, linked the book to the radical* political tradition, especially Thomas Paine's* *Rights of Man* (1791). Although these links made the book popular in America and France, in Britain many were alarmed by the way that the French Revolution had swept away old forms of government and ways of life. Indeed, people were worried that a similar revolution might take place in Britain. To these hostile readers, any suggestion of radical reform toward "rights" implied the overthrow of all government, order, and tradition. The conservative writer Hannah More,* for example, was "invincibly resolved" not to read the book at all before condemning it, sneering that "there is something fantastic [strange and implausible] and absurd in the very title."[8]

To some extent Wollstonecraft anticipates these objections, and openly argues against them throughout the book. "The fear of innovation,* in this country," she acknowledges, "extends to every thing," but she argues throughout that it is rational* to suggest changes to society if they are beneficial.[9] She is also aware that by writing a book about philosophy and politics, she is abandoning the "weak elegancy of mind, exquisite sensibility, and sweet docility of manners*" expected of a woman. Instead of these qualities, though, Wollstonecraft claims what she thinks of as the more authentic "manly virtues*" of moral reason.*[10]

Limitations

Wollstonecraft was aware that a female writer who argued in a direct style for radical change was likely to be greeted by "exclamations against masculine women," by men who wanted to put her in her place.[11] Prejudice against Wollstonecraft as a revolutionary woman limited the extent to which *Rights of Woman* was read and cited, especially by other women, and especially after British public opinion turned against revolutionary ideas in the mid-1790s. In the more socially conservative atmosphere of nineteenth-century Britain, Wollstonecraft's work continued to be well known, but had been almost completely discredited by attacks on her personal life and her political radicalism. Victorian feminists, keen to appear socially and intellectually respectable, tended to distance themselves from the "wildness of the Wollstonecraft school, and all its ultra-theories."[12]

With the emergence of more openly radical forms of feminism in the 1970s, Wollstonecraft's "wildness," her reputation as a revolutionary, and the boldness of *Rights of Woman* were reevaluated as positive qualities, making the book compelling to readers inside and outside academia. With feminist methods and ideas now important to a huge range of disciplines, Wollstonecraft's basic principles of feminism are relevant across a wide spectrum of subjects. At almost the same time, increasing interest in philosophy in questions of race and class has pointed out various weaknesses in Wollstonecraft's claim to discuss the place of all women in all societies, noting that she often implicitly excludes working-class, nonwhite, and non-Christian women from her definitions. As a result, scholars have recently turned to *Rights of Woman* as a historical document as well as a philosophical treatise.*[13]

NOTES

1 Mary Wollstonecraft, letter to William Roscoe (January 3, 1792), in *The Collected Letters*, ed. Janet Todd (London: Penguin, 2003), 193–94.

2 William Godwin, *Memoirs of the Author of 'The Rights of Woman'*, ed.
 Richard Holmes (London: Penguin, 1987), 232.

3 Mary Wollstonecraft, *A Vindication of the Rights of Woman*, in *A Vindication
 of the Rights of Woman and A Vindication of the Rights of Men*, ed. Janet
 Todd (Oxford: Oxford University Press, 2008), 69.

4 These are reproduced in Adriana Craciun (ed.), *Mary Wollstonecraft's* A
 Vindication of the Rights of Woman: *A Sourcebook* (Abingdon, Routledge,
 2002), 161–65.

5 Wollstonecraft, *Rights of Woman*, 69.

6 Godwin, *Memoirs of the Author*, 232.

7 Hannah Cowley, *A Day in Turkey; or, The Russian Slaves* (London: Robinson,
 1792), "Advertisement."

8 Hannah More, letter to Horace Walpole (18 August 1792), in *Horace
 Walpole's Correspondence with Hannah More*, ed. W. S. Lewis (New Haven:
 Yale, 1961), 370.

9 Wollstonecraft, *Rights of Woman*, 243.

10 Wollstonecraft, *Rights of Woman*, 72–73.

11 Wollstonecraft, *Rights of Woman*, 72.

12 Jessie Boucherett, "Maria Edgeworth," in *English Woman's Journal* 2
 (1858), 11. Quoted in Barbara Caine, "Victorian Feminism and the Ghost of
 Mary Wollstonecraft," in *Women's Writing* 4.2 (1997): 261–75, 261.

13 Harriet Guest, *Small Change: Women, Learning, Patriotism, 1750–1810* 6
 Evans, *Kierkegaard's Christian Psychology*, 21.

PLACE IN THE AUTHOR'S WORK

KEY POINTS

- Through her body of work, Mary Wollstonecraft consistently argues for the idea of moral reason* and supports her belief that all people, including women, share the right and the responsibility to act rationally.*

- *Rights of Woman* developed the themes of Wollstonecraft's wider work, and focused for the first time on how these themes could be applied to questions of gender*—roughly, the state of being male or female—and the rights of women.

- Because of its originality, *Rights of Woman* has consistently been regarded as Wollstonecraft's most important (if not her best-written) political text.

Positioning

Mary Wollstonecraft wrote *A Vindication of the Rights of Woman* at the midpoint of her short but intensive career. It offers a snapshot of her thought at a time when her ideas and opinions were rapidly evolving, and it is usually seen as a companion piece to her earlier *Vindication of the Rights of Men* (1790). As these titles suggest, the two books are based around similar arguments, but in *Rights of Men* Wollstonecraft focuses on the universal* roles and rights of all people in society (using "men" to mean "mankind" or "humanity"—although many of her sources use the word to mean male citizens* only). In contrast, *Rights of Woman* focuses on women in particular.

Rights of Men included some references to the debates over the role and virtues* of women, which Wollstonecraft would develop in the

> ❝ Do we call her a novelist? An educationist? A
> political theorist? A moral philosopher? An historian?
> A memoirist? A woman of letters? A feminist?
> Wollstonecraft was all of these things, of course, but to
> describe her as any single one of them would ... diminish
> the range as well as the wholeness of her achievement. ❞
>
> Claudia L. Johnson, Introduction to *The Cambridge Companion to Mary Wollstonecraft*

later work. For example, she imagines an upper-class woman who benefits from radical* reform by "[becoming] a rational woman" and thus a better, more serious wife and mother.[1] She also criticizes the conservative* writer Edmund Burke* for promoting an idea of "natural" gender characteristics that discourages his female readers from aiming to "exercise their reason* to acquire the virtues" of moral reason.[2] By doing this, she argues, he dehumanizes them—he denies them their humanity.

Rights of Woman, though, expands these arguments to articulate a stronger and more coherent theory of the role of women and the problems of gender essentialism* (that is, the belief that women are born with innate qualities that differ from those of men). By doing this, she disagrees with some of the male philosophers who had inspired and guided *Rights of Men*, and takes a more individual intellectual course.

Wollstonecraft would go on to explore these themes in a gothic novel,* *The Wrongs of Woman, or Maria.* The main character of this book, victimized and imprisoned by her all-powerful husband, describes "the world [as] a vast prison, and women born slaves."[3] *Rights of Woman*, then, addresses questions and ideas that interested Wollstonecraft all her life, although it is the only one of her nonfiction works to discuss them in detail.

Integration

Wollstonecraft's body of work is linked by a constant interest in a few fundamental principles.

- the right of all adults to follow their own reason
- the belief that following their own reason was a Christian moral duty for people
- the effect of environment, and especially education,* on the character* and development of individuals.

However, in their details and tone, Wollstonecraft's works often seem fragmented and even contradictory. They were usually written quickly, as the writer was working through her ideas and opinions. Perhaps because she died young, she never wrote a large-scale, summarizing work that explained and settled her philosophy.

As well as this process of intellectual development, the differences between the details of her arguments can often be attributed to changes in the historical and personal circumstances in which Wollstonecraft was writing. For example, her attacks on "mistaken notions of female excellence"[4] in *Rights of Woman* are far more radical than those expressed in her earlier stories for children and in *Thoughts on the Education of Daughters* (1786),[5] which suggested that girls be taught to resign themselves to the roles expected of them by society. This may be because, at the time of writing the earlier works, she needed money and knew that a more conventional approach would sell.

Wollstonecraft also adjusted her support for the French Revolution* in response to the real-life events and developments in Revolutionary France, with which she was often disappointed. So, in 1790, the new French government's exclusion of women from rights of citizenship and equal education prompted Wollstonecraft to write *Rights of Woman*. Soon afterward, between 1793 and 1794, France

experienced the Terror,* a period marked by extreme repression and violence, and conflict between revolutionary groups. Wollstonecraft's next work, *An Historical and Moral View of the Origin and Progress of the French Revolution* (1794),[6] attempted to reconcile the ideals of her work in the *Vindications* with the reality of the Terror.

As well as the political polemic* of *Rights of Woman*, Wollstonecraft also experimented with travel writing and fiction. In her theoretical works (including *Rights of Woman*), Wollstonecraft argued that the only way to be virtuous is to follow reason, and that giving way to irrational emotion is self-indulgent and misleading. But her novels, such as *The Wrongs of Woman*, aim to move their readers emotionally, and define good characters in terms of their sensitivity to emotion.

Significance

Rights of Woman is Wollstonecraft's most original book and her most famous. In her own time the book added considerably to her reputation as a formidable thinker. While this reputation had already been established by her earlier books, the title of the memoir* of Wollstonecraft published by her husband William Godwin* identifies her only as "*the Author of a Vindication of the Rights of Woman*"[7]— evidence that this was her best-known work.

Although *Rights of Woman* continued to be read to some extent through the nineteenth and early twentieth centuries, Wollstonecraft's reputation was more closely linked to her unorthodox personal life. This was sometimes vilified and sometimes romanticized as a rebellion against the oppressive forces she condemned in her books. She was also known for her connections to famous intellectual figures such as her husband William Godwin, her daughter Mary Shelley* (the author of the novel *Frankenstein*), and her daughter's husband, the Romantic* writer, Percy Bysshe Shelley.* Though many people in this period knew that Wollstonecraft had written a feminist* treatise,* few had actually read it.

Wollstonecraft's writings eventually returned to prominence in the 1970s and 1980s, when feminist scholars began to research and promote the history of feminist thought. At this time, *Rights of Woman* was again seen as the central text of her body of work and as the text most explicitly concerned with women's rights. Today, the impact of *Rights of Woman* as a foundational text of modern feminism gives it huge significance in Western history and philosophy.

NOTES

1 Mary Wollstonecraft, *Vindication of the Rights of Men*, in *A Vindication of the Rights of Woman and A Vindication of the Rights of Men*, ed. Janet Todd (Oxford: Oxford University Press, 2008), 23.

2 Wollstonecraft, *Rights of Men*, 46.

3 Mary Wollstonecraft, *The Wrongs of Woman, or Maria*, in *Mary, A Fiction and The Wrongs of Woman, or Maria*, ed. Michelle Faubert (London: Broadview, 2012), 167.

4 Wollstonecraft, *Rights of Woman*, 75.

5 Mary Wollstonecraft, *Thoughts on the Education of Daughters, With Reflections on Female Conduct in the Most Important Duties of Life* (London, Joseph Johnson: 1786), LSE Digital Library, accessed November 24, 2015, http://digital.library.lse.ac.uk/.

6 Mary Wollstonecraft, *An Historical and Moral View of the Origin and Progress of the French Revolution*, in Wollstonecraft, *A Vindication of the Rights of Woman and A Vindication of the Rights of Men*, ed. Janet Todd (Oxford: Oxford University Press, 2008), 285–372.

7 William Godwin, *Memoirs of the Author of 'The Rights of Woman'*, ed. Richard Holmes (London: Penguin, 1987).

SECTION 3
IMPACT

MODULE 9
THE FIRST RESPONSES

KEY POINTS

- The first critics of *A Vindication of the Rights of Woman* were divided by their political sympathies. Liberal* readers (followers of a political philosophy arguing, roughly, for greater liberty in a reformed version of the present political and social system) ignored the book's radical* political implications—that is, that revolutionary social and political change was required. Conservative* readers, meanwhile, attacked Mary Wollstonecraft as a dangerous radical in the tradition of the political philosopher Thomas Paine.*

- One of the most important responses to *Rights of Woman* came from Wollstonecraft's husband William Godwin.* His account of the book and its reception, in his memoir* of Wollstonecraft, established the idea of *Rights of Woman* as a radical and controversial text.

- The perception of Wollstonecraft's personal life as scandalous or unorthodox had an important effect on the reception of *Rights of Woman*.

Criticism

When it was first published in 1792, Mary Wollstonecraft's *A Vindication of the Rights of Woman* sold well, and many British liberal journals reviewed it positively. But historians have pointed out that most of these reviews regarded the book as an "innocuous," if "fanciful," educational treatise,* and did not recognize the broader and more radical claims Wollstonecraft had made about the status and natural character* of women.[1]

While American and French audiences took the text somewhat

> ❝ Not everyone understood the far-reaching consequences of Mary's arguments. Those who did thought they seemed dangerous—even her admirers did not fully support how she had enlarged the discussion. Indeed, by daring to connect the condition of women to the distribution of wealth and power, she became the target of brutal attacks. ❞
>
> Charlotte Gordon, *Romantic Outlaws: The Extraordinary Lives of Mary Wollstonecraft and Mary Shelley*

more seriously and positively, in her home country it was British conservative opponents of revolutionary philosophy that identified Wollstonecraft's radicalism. An anonymous critic of the book called her "the first female combatant in the new field of the Rights of Woman."[2] However, they seized upon the logical strength of her arguments as a way of attacking the idea of universal* rights on which these arguments were based. Wollstonecraft was quite correct, these commentators asserted, that a political and social revolution following the principles of Thomas Paine or Jean-Jacques Rousseau* should logically give equal rights to women. "Her doctrines," explained one of the most scathing critiques, "are almost all obvious corollaries from the theorems of Paine."[3] But unlike Wollstonecraft, they presented as absurd this idea of an equal society in which it was not necessary to acknowledge gender—a terrible warning of the dangers of revolutionary thought. After all, argued one critic, if women were educated and given freedom, they would no longer agree to carry out boring, demeaning but necessary domestic* duties such as childcare or nursing the sick. Nor would they need to learn "the softer arts of pleasing."[4] For conservative critics, a social order founded on revolutionary ideals, if it was consistent, would be full of uncaring, unattractive women; famously referred to in one poem as "Unsex'd Females."[5]

Another attack, a poem called *A Vindication of the Rights of Brutes* (1792), suggested sarcastically that "the wonderful productions of Mr. Paine and Mrs. Wollstonecraft" would logically lead to claims that animals, plants, and things also deserved rights and equality.[6] At the same time, after the violence of the post-revolutionary Terror* in France in the 1790s, general opinion turned against Wollstonecraft's liberal principles and sympathies. As one of her modern biographers has noted, by the beginning of the nineteenth century, "the tide of opinion flowed so strongly against philosophical radicalism that supportive voices were soon drowned in the hostile clamor."[7]

Responses

Wollstonecraft died less than five years after the publication of *Rights of Woman*, and much of this time was taken up by personal crises or travel to France and Scandinavia. She never directly responded to criticisms of the book in public, although she had anticipated many of them in its introduction, where she argues against her critics' "exclamations against masculine women."[8] However, it could be argued that Wollstonecraft's decision to abandon the planned second volume of *Rights of Woman*, and turn from political philosophy to history, travel writing, and fiction was motivated by these attacks and satires, and her fear that they had damaged the wider cause of radical politics. In her novels, in particular, Wollstonecraft sought a safer way to express feminist* ideas, and presented women of reason* as sensitive, emotional, and therefore approachably feminine,* in contrast to the caricatures of "Unsex'd Females" presented by her opponents.

Despite this, attacks on *Rights of Woman* intensified after her husband, William Godwin, published a posthumous memoir of her life. The book praised and defended her, but also revealed aspects of her private life—such as her illegitimate child and attempted suicide—that were scandalous at the time. These encouraged conservatives to hold her life up as evidence that a woman who followed the principles

of *Rights of Woman* would become "Unsex'd," disobedient and unhappy. Godwin's memoir also emphasized the radical nature of *Rights of Woman*, insisting that it "shocked the majority" of readers.[9]

These texts and arguments shaped subsequent debates on *Rights of Woman* by establishing a perception of the book as radical, defiant, and original. For many later feminist writers, the horrified reactions of Wollstonecraft's critics to the idea of a thinking, independent woman help to reveal the real inequalities and exploitation behind eighteenth-century ideas about gender.*

Conflict and Consensus

In the context of an increasingly conservative British culture suspicious of women writers, both the ideas in *Rights of Woman* and those of Wollstonecraft's wider body of work proved too radical and uncompromising to be accepted or even taken seriously. Most of the liberal and radical readers who supported Wollstonecraft's other political arguments—those made in *Vindication of the Rights of Men*, for example—were men, and had little sympathy for women's claims to equality. Many feared that their cause would be damaged if it continued to be associated with the scandal of Wollstonecraft's life, or with "unfeminine" female claims to political and intellectual roles. Within a decade of its publication, then, a hostile consensus was established among political commentators, academics, and general readers.

As attitudes to women in the wider world (and especially in academia) have slowly shifted in the subsequent two centuries, *Rights of Woman* has been reconsidered from new perspectives. Critics are now more likely to focus on its status as a document of the history of philosophy and feminism, than debate it as a polemical* political text or guide to education. Nevertheless, some of its central points remain provocative, especially Wollstonecraft's argument that feminine characteristics are caused by education* and environment, an

argument founded on a controversial rejection of gender essentialism*
(the belief that women are born with natural qualities or characters
different from those of men).

NOTES

1 R. M. Janes, "On the Reception of Mary Wollstonecraft's *A Vindication of the Rights of Woman*," in *Journal of the History of Ideas* 39.2 (1978): 295.

2 *Critical Review* 4, in *Broadview Anthology of British Literature*, concise edition, ed. Joseph Black et al. (London: Broadview, 2007), vol. B, 81.

3 Robert Bisset, in the *Anti-Jacobin Review* (1798), in *Mary Wollstonecraft's* A Vindication of the Rights of Woman: *A Sourcebook*, ed. Adriana Craciun (Abingdon: Routledge, 2002), 46.

4 *Critical Review*, 81.

5 Richard Polwhele, *The Unsex'd Females*, in Craciun, *Sourcebook*, 44–45.

6 Thomas Taylor, *A Vindication of the Rights of Brutes* (1792), in Craciun, *Sourcebook*, 40.

7 Barbara Taylor, *Mary Wollstonecraft and the Feminist Imagination* (Cambridge: Cambridge University Press, 2003), 28.

8 Mary Wollstonecraft, *A Vindication of the Rights of Woman*, in *A Vindication of the Rights of Woman and A Vindication of the Rights of Men*, ed. Janet Todd (Oxford: Oxford University Press, 2008), 72.

9 William Godwin, *Memoirs of the Author of 'The Rights of Woman'*, ed. Richard Holmes (London: Penguin, 1987), 232.

MODULE 10
THE EVOLVING DEBATE

KEY POINTS

- Mary Wollstonecraft's original concepts in *A Vindication of the Rights of Woman* helped make it possible for later feminists* to develop their arguments about the character,* potential, and place of women.

- *Rights of Woman* has inspired thinkers and activists in a very broad school of thought, all linked by their feminism. It has been read and used in different, sometimes opposing ways by feminist thinkers.

- Central to feminism, and to academic and political debates today, is the process of analyzing texts to show how they create or reinforce readers' ideas and assumptions. This was a project started by Wollstonecraft in *Rights of Woman*.

Uses and Problems

Mary Wollstonecraft was regarded as a controversial and scandalous figure for most of the early nineteenth century, though her *Vindication of the Rights of Woman* remained available. Writers who admitted to being influenced by her ideas, however, would be attacked, laughed at, or dismissed—an explanation of why her friend, the English writer and early feminist Mary Hays,* followed arguments from *Rights of Woman* in her novels and political works but avoided citing the book directly.

This attitude changed with the development of organized feminist political movements in Britain and the United States in the late nineteenth century. Feminism always aims to improve the position of women in society, but these movements—sometimes summarized as

> 66 [Mary Wollstonecraft] is alive and active, she argues and experiments, we hear her voice and trace her influence even now among the living. 99
>
> Virginia Woolf, "Four Figures"

"waves"—have historically focused on different issues and problems. As a result, each wave has interpreted and used Wollstonecraft's ideas in different ways and for different purposes. As feminist thought has become more established and developed, the aura of scandal and radicalism* that led to the work's suppression in the anti-feminist nineteenth century has become the source of its appeal. As one historian pointed out in the 1970s, "those elements that disturbed the work's first readers account for the continuing hospitality of its modern audience."[1] The critic Elaine Showalter* notes that *Rights of Woman* "anticipates virtually every idea of modern feminism"—but these ideas are complex and sometimes contradictory.[2]

In the 1980s, scholars also began to point out the conservative* aspects and limitations of Wollstonecraft's work, viewing it not only as a challenge to prejudices about gender,* but a document of prejudices linked to class, race, religion, and sexuality. It has also come to be analyzed as a work of literature, and seen as a text linked to the eighteenth- and nineteenth-century movement of Romanticism* in art and literature, as well as politics. Wollstonecraft is now frequently included in anthologies and university syllabuses on Romantic literature.

Schools of Thought

British and American "first-wave feminism" in the late nineteenth and early twentieth centuries was, broadly speaking, concerned with acquiring educational and political opportunities for women. These first-wave feminists were influenced by Wollstonecraft's argument in

Rights of Woman that it is a benefit to society for women to become educated, rational,* and virtuous.* However, they developed this idea into concrete demands for legal and political changes that Wollstonecraft did not consider directly or in detail, such as the right to attend universities or to vote.

At the same time, activists campaigning for women's social, sexual, and emotional liberation, like the anarchist* Emma Goldman* and the writer Virginia Woolf,* both regarded Wollstonecraft as one of "the Pioneers of human progress."[3] They emphasized the importance of emotion, freedom, and rebellion in their essays, seeing her feminism as best expressed through her life and manners* rather than her writing.

"Second-wave feminism" in the 1960s and 1970s continued this interpretation of Wollstonecraft as a radical, romantic rebel. In this period, academic and political feminists debated questions of gender essentialism* and the "natural" place of women. *Rights of Woman* was cited by second-wave feminists because of its challenges to the assumption that feminine* characteristics were produced by biology rather than environment. However, because it emphasizes the importance of women being good mothers and wives, more conservative feminists could also use *Rights of Woman* as an example of a feminist intellectual tradition that imagined women as free and fully human, but also as primarily domestic* and maternal.

In Current Scholarship

Today, feminist theorists like Judith Butler* share Wollstonecraft's basic principle that men and women have the same essential nature, humanity, or soul.* However, they extend this idea to argue that all gender-based social roles—and even gender itself—are the artificial products of social conventions and culture. To show how this works, a school of feminist cultural criticism* has developed (cultural criticism is the practice of analyzing books, images, or films, to show how these

work together to produce certain ideas, beliefs, and systems). This can be seen as continuing the project that Wollstonecraft began in *Rights of Woman*, in which she dissects books, manners, and educational practices to show how writers and texts can (deliberately or unconsciously) create, reinforce, or challenge differences between men and women that then appear to be natural.

Today, this process of analysis is central to feminists working in academic disciplines including social studies, media studies, literary criticism, and art history. However, over the last decade, academics have increasingly expanded these basic principles to look also at the ways that culture creates particular ideas about other forms of difference, such as race, class, sexuality, and disability, and at how these ideas are often linked to each other.

This project has also reached popular culture in different ways—in the form of feminist blogs and magazines, for example, or in popular political campaigns such as the British "Let Toys Be Toys" campaign in 2012. This made the point that marketing toys by gender (such as dolls labeled as suitable for girls, and construction sets or toy weapons for boys) encourages children to adopt damaging stereotypes* in their behavior and interests. Although this campaign goes further in its arguments and demands than Wollstonecraft did in *Rights of Woman*, it can be seen as following the same basic principles: that childhood environment shapes character, and that an artificial insistence on differences between boys and girls is bad for their development.

NOTES

1 R. M. Janes, "On the Reception of Mary Wollstonecraft's *A Vindication of the Rights of Woman*," in *Journal of the History of Ideas* 39.2 (1978): 302.

2 Elaine Showalter, *Inventing Herself: Claiming a Feminist Intellectual Heritage* (London: Picador, 2001), 21.

3 Emma Goldman, "Mary Wollstonecraft, Her Tragic Life and Her Passionate Struggle for Freedom," reprinted as "Emma Goldman on Mary Wollstonecraft," ed. Alice Wexler, in *Feminist Studies* 7.1 (1981): 114.

MODULE 11
IMPACT AND INFLUENCE TODAY

KEY POINTS

- *A Vindication of the Rights of Woman* has become both a well-read classic in political philosophy and a symbol of feminism's* history and achievements.

- Mary Wollstonecraft's ideas about the cultural influences on the production of gender* characteristics continue to challenge strongly held views about the natural differences between men and women.

- Opponents of *Rights of Woman* point to ideas from science and religion that see gender differences as fixed and innate. Other critics argue that Wollstonecraft's cultural criticism* (analyzing texts to show how they work together to produce certain ideas, beliefs, and systems) did not go far enough, because it does not challenge contemporary beliefs about the differences between races and classes as well as gender.

Position

Many of the key ideas in Mary Wollstonecraft's *A Vindication of the Rights of Woman* are now very widely accepted in Western academia and public thought, or have been significantly developed since the book was published in 1792. As a result, it is now mainly read either as an introduction to the basic ideas and origins of feminist philosophy, or as an inspiring historical document.

Political feminists hold up Wollstonecraft as symbolic of the history and achievements of women, while they view *Rights of Woman* and its hostile reception as striking examples of the bravery and persecution of feminist thought in the past. One cultural critic writes that

> **❝** Who can say that we women are not now all members of the new genus Wollstonecraft so brazenly constructed? Or that each of us does not benefit? **❞**
>
> Toni Bentley, " 'Vindication': Mary Wollstonecraft's Sense and Sensibility," review in the *New York Times*

contemporary feminism has "adopted Wollstonecraft as an icon for its success in placing women's rights and sexual difference at the center of social and political debates." This centrality, she explains, has made "the genealogy of feminist ideas in modernity of interest to a wider public," so that Wollstonecraft is now viewed not as an obscure or marginal figure but as a mainstream historical icon.[1] In other words, by presenting Wollstonecraft's *Rights of Woman*, with its defiance of the rules and expectations of eighteenth-century British society, as a landmark in Western thought, feminist historians promote the importance of women and gender in history.

For example, a feminist charity based in London began in 2011 to campaign and raise funds for a public statue of Wollstonecraft to be displayed near her former home. In support of this campaign, the academic and TV presenter Mary Beard* argued that "every woman who wants to make a difference to how this country is run, from the House of Commons to the pub quiz, has Mary Wollstonecraft to thank." That is, her influence has transformed women's rights and roles in British society.[2]

Interaction

By encouraging the education* of women and their participation in intellectual life, *Rights of Woman* has broadly and indirectly helped to shape almost every academic and scientific field in Western thought. More specifically, its ideas continue to be debated in the context of

controversies around gender, feminism, and social equality.

Some political, economics, and business commentators argue that the feminist principle, central to *Rights of Woman*, that men and women are essentially similar, is wrong, or at least overstated. They point to evidence drawn from the study of evolutionary biology and neuroscience, which suggests that major personality and behavior differences are caused by differences between male and female bodies and brains, so that "there is actually hard science behind many of our stereotypical* gender roles."[3] Alternatively, they follow the many religious doctrines and traditions that give different roles and destinies to men and women. For example, the Roman Catholic Church maintains that "the importance and the meaning of sexual difference, as a reality deeply inscribed in man and woman, needs to be noted."[4]

In general, the feminist schools of thought that follow Wollstonecraft's *Rights of Woman* challenge these scientific or religious positions by stressing the artificial, social production of "sexual difference." They argue that science and religion themselves are shaped by prejudices, and analyze how both act in turn to shape the behavior and characteristics of men and women. These questions remain controversial not only to academics but among the public, since they have direct consequences in politics and public policy.

In discussions about the reasons fewer women than men have careers in science and technology, for example, a feminist opposed to gender essentialism* might argue that this is because women are discouraged from participating in science by biases in education, culture, and the expectations of society. Furthermore, they might argue that practical measures (such as education and publicity campaigns, quotas or scholarships for female students, or mentoring schemes) should be introduced to balance these. In contrast, someone who believes in essential differences between genders might argue that women naturally have less interest in and talent for science than men, so that such interventions are unnecessary and unhelpful.

The Continuing Debate

In a well-known 1993 article called "The Sultan and the Slave," the Egyptian American critic Joyce Zonana* draws attention to Wollstonecraft's use of metaphors comparing the oppression of European women to slavery or the stereotypical imprisonment of Muslim women in harems.* She criticizes Wollstonecraft as a "feminist orientalist*" who "uncritically associates the East with despotism and tyranny."[5] This not only implies that women who are not white and Christian like Wollstonecraft are excluded from her definition of "all" women as rational* humans, but also promotes the idea that the West is inherently more progressive* and civilized, especially in its treatment of women, than Muslim cultures.

Following on from Zonana's work, other critics have analyzed Wollstonecraft's language and implications in *Rights of Woman*, and pointed out her patronizing treatment of working-class women, and her hostility to homosexuality. Both are attitudes that were conventional at the time but are increasingly seen as unacceptable among feminist thinkers. This kind of criticism is often aimed less at *Rights of Woman* itself than at the book as an emblem for the longer tradition of Western feminist thought. Because of her status as a founder of this tradition, Wollstonecraft's exclusions and limitations have been used to illustrate the wider exclusions and limitations of the Western tradition of feminism more generally, which is sometimes accused of promoting the interests of white, middle-class women and sidelining or denigrating other groups of women.

NOTES

1 Cora Kaplan, "Mary Wollstonecraft's Reception and Legacies," in *The Cambridge Companion to Mary Wollstonecraft*, ed. Claudia L. Johnson (Cambridge: Cambridge University Press, 2002), 246.

2 Bee Rowlatt, "The Original Suffragette: The Extraordinary Mary Wollstonecraft," The *Guardian*, October 5, 2015.

3 Lewis Wolpert, "Yes, It's Official, Men are from Mars and Women from Venus, and Here's the Science to Prove It," *Telegraph*, September 14, 2014.

4 Pope John Paul II, "Letter to the Bishops of the Catholic Church on the Collaboration of Men and Women in the Church and the World," May 31, 2004, accessed November 20, 2015, http://www.vatican.va/roman_curia/ congregations/cfaith/documents/rc_con_cfaith_doc_20040731_ collaboration_en.html.

5 Joyce Zonana, "The Sultan and the Slave: Feminist Orientalism and the Structure of *Jane Eyre*," in *Signs* 8.3 (1993): 599.

MODULE 12
WHERE NEXT?

KEY POINTS

- While *Rights of Woman* may not have the political impact in the future that it has had in the past, it is likely to continue as a significant academic and symbolic text for modern feminists.*

- Despite increased awareness of its limitations, *Rights of Woman* will be remembered as a classic, foundational text for the wider debate over the role and rights of women around the world.

- It may have a role in new debates about women's education,* cultural change, and globalization.*

Potential

Now more than two hundred years old, Mary Wollstonecraft's *A Vindication of the Rights of Woman* is as widely read and studied as it has ever been. As many academic disciplines, especially history, are gradually highlighting women writers and the concerns and lives of women, *Rights of Woman* appears increasingly frequently in school and university syllabuses. It also features more often in academic research, as a classic work of literature, political philosophy, and education and legal theory. This trend seems likely to continue in the future.

If any of the specific demands and examples in Wollstonecraft's book are no longer immediately relevant, this is either because they relate to a historical context that has changed or because its ideas have now been widely accepted; many readers already believe, for example, that girls should receive an academic education of some kind. Nevertheless, the basic principles of *Rights of Woman* have been used to

> 66 Luckily for her admirers and detractors alike,
> Wollstonecraft is too volatile and too evasive a figure
> to become even a fixed point of unstable reference,
> and will go on to act as a constant provocation to her
> interlocutors. 99
>
> Cora Kaplan, "Mary Wollstonecraft's Reception and Legacies"

construct a range of arguments and methods that remain important and often controversial. This is not just in academia, but also in political and popular culture more generally.

As a symbolically and historically important text, *Rights of Woman* will continue to provide material for debates between the many different schools of thought in modern feminism, as it has in the past. At the same time, in the ongoing backlash against feminist politics since her own time, Wollstonecraft's work may be used as evidence that the revolution she initiated has now gone much further than she originally intended, particularly regarding her acknowledgements of the physical weakness of women and the importance of motherhood and domesticity.*

Future Directions

The traditions and projects influenced by Wollstonecraft's ideas in *Rights of Woman* are very broad and diverse. In academia, her project of feminist or political cultural criticism* is now well established, and is likely to last for many years. This project is increasingly widening to consider questions of race, class, disability and sexuality as well as gender,* with theorists such as Susan Bordo* combining ideas from psychology and postmodernism* (an approach to the analysis of culture that challenges traditional understandings regarding knowledge and meaning) with Wollstonecraft's broad political

concepts. Wollstonecraft's aim of challenging assumptions and producing radically new ideas of gender is also continuing in work by feminist philosophers like Judith Butler.*

More widely, feminist ideas will continue to influence public debate and policy in societies around the world. Wollstonecraft's emphasis on the need for a "revolution in female manners"*[1] is echoed in campaigns that encourage women to improve their economic and social position by becoming more assertive and less dependent on men. Thinkers as different as the business leader Sheryl Sandberg* and the novelist Chimamanda Ngozi Adichie* can be seen as Wollstonecraft's successors in their writing and in their activism for these campaigns, now and in the future.

Finally, the idea expressed in *Rights of Woman* that education for girls is vital not only for their own well-being but for the progress of their society in general has become a globally significant, if sometimes controversial, principle. Its importance to the work of activists in many different countries and cultures—most famously, the Pakistani teenager and Nobel Prize-winner, Malala Yousafzai*—suggests that this idea, interpreted in new ways, will continue to prompt reform and revolution in the future.

Summary

Wollstonecraft's *Rights of Woman* laid the foundations of the transformational movement now known as feminism. Reading the book today provides us with an account of the historical context from which this movement would emerge, and an introduction to some of its basic principles and concepts. It is also a landmark text in the history of the law and of education.

The seminal argument of *Rights of Woman* is that men and women share an ability to reason,* which makes them fully human, moral beings with equal rights. If the progress of a society depends on its male citizens* being educated and given freedom to follow their

reason (as Enlightenment* philosophers had argued and the French Revolution* put into practice), Wollstonecraft argues that it also needs women to receive the same freedom and education. A culture—such as that of the Britain in which she lived—that emphasizes essential, natural differences between men and women, in fact *creates* many of these differences by encouraging women into roles of weakness, passivity and irrationality that they then live up to. Many women become victims of these prejudices: forced to depend intellectually, morally, and economically on men who may be unable or unwilling to support them. At the same time, the characteristics imposed on women, especially those in the middle and upper classes, make them unsuited for the responsibilities of motherhood or managing a household.

Wollstonecraft articulates her key principles with such logical and emotional force that her most conservative* enemies have found it difficult to pose a coherent counterargument—despite neglect of her work, scandal surrounding her life, mockery, and arguments over interpretations and applications. Wollstonecraft's own writing, both rational* and openly female (since she published under her own name rather than anonymously—in which case readers may have assumed she was a man), is proof of her argument that women are capable of reason. Her extraordinary life and personality, as well as the power and significance of her work, have given *Rights of Woman* enduring appeal.

NOTES

1 Mary Wollstonecraft, *A Vindication of the Rights of Woman*, in *A Vindication of the Rights of Woman and A Vindication of the Rights of Men*, ed. Janet Todd (Oxford: Oxford University Press, 2008), 113.

GLOSSARY

GLOSSARY OF TERMS

Anarchism: a political system in which the government does not control individuals through force or law.

Character: for Mary Wollstonecraft and her contemporaries, character signifies the qualities, abilities, and moral behavior of a person.

Citizen: a person who has full legal and political rights in a country.

Conduct book: a book that gives readers advice about how they should behave. Conduct books were popular in eighteenth-century Britain.

Conservatism: a belief that all forms of change are to be avoided, and that political, social, and other systems should be based as much as possible on tradition and stability.

Cultural criticism: an academic practice of analyzing texts, such as books, images or films, to show how these work together to produce or challenge certain ideas, beliefs, and systems.

Dissenting Christians: British Protestant Christian believers who disagreed with the established state church, and separated themselves as individuals or in groups. In the eighteenth century, religious dissent was sometimes associated with a belief in political, social, and intellectual freedom.

Domesticity: the work inside a home, concerned with activities such as cooking, cleaning, and caring for a family.

Education: for Wollstonecraft, the whole upbringing of a child, with all the influences on his or her knowledge and character.

The Enlightenment: a philosophical movement of the late seventeenth to the late eighteenth century, according to which ideas and behavior should be based on experience, science, and logic, rather than tradition and authority.

Essentialism: the belief that certain groups of people (such as women or working-class people) are born with natural, innate qualities or characters, different from those in other groups (such as men or upper-class people).

Feminine: traditionally or widely believed to be characteristic of women, or appropriate for women.

Feminism: a political and intellectual movement founded on the belief that men and women should be treated equally, and that political, academic, or social activism is necessary to achieve this.

French Revolution: an uprising in France between 1789 and 1799, in which the French king was overthrown and executed, and radical new social and political systems were introduced.

Gender: the state of being male or female, or of having the character usually associated with being male or female.

Gender blindness: not acknowledging or differentiating people by gender.

Gender essentialism: the idea that nature gives men and women different bodies, and so naturally opposing characters and purposes in life.

Globalization: the process of global interaction, exchange and integration of views, products, ideas and other aspects of culture.

Gothic novel: a type of book common in Britain in Wollstonecraft's time, telling a frightening or shocking story, often set in the past.

Harem: Wollstonecraft and most other Europeans in the eighteenth century believed that a harem was a place where male Muslim rulers imprisoned their wives and concubines.

Hierarchy: a system of organizing society so that people belong to different levels with different amounts of power.

Innovation: the creation of something new.

Lady's companion: a paid companion for women of rank or wealth, often coming from a similar class to that of the employer. Duties would include providing conversation and good company.

Liberalism: in eighteenth-century Britain, the belief that the government should be changed, to create a more equal, freer society.

Manners: for Wollstonecraft and her contemporaries, all the ways that a person acts and treats others.

Memoir: a book that describes the life of a person, usually by somebody who knew him or her well.

Minister: a leader in a Protestant Christian church.

Moral reason: a philosophical concept created and promoted by the Enlightenment. The ability to use logic to decide if an action is right or wrong.

Natural rights: for some political philosophers, things that every human is entitled to do or have (such as freedom or property).

Orientalism: an attitude toward cultures in the Middle East, North Africa, and Asia, which sees them as fundamentally different (and implicitly inferior) to the West.

Personhood: the status or quality of being a human individual.

Polemic: a piece of writing that directly attacks an opinion or theory, intended to persuade readers of the writer's point of view.

Postmodernism: in the field of literature, philosophy, and the arts, "postmodernism" refers to an approach to the analysis of culture and texts that challenges long-held assumptions regarding objectivity, knowledge, and meaning, sometimes using the theoretical tools of linguistics, psychoanalysis, and literary criticism (among others).

Primary education: the first stage of school education, in Britain usually for children up to the age of eleven.

Progressive: a state of mind that is supportive of new ideas, believing that change and innovation can improve a society.

Protestantism: one of the two major branches of the Christian faith, generally understood to have been founded in 1517 with the schism, known as the Protestant Reformation, with the Roman Catholic branch of Christianity.

Radicalism: the belief that major, revolutionary change is necessary to make the world better.

Rationality: actions that are based on logic and experience, rather than (for example) belief, tradition, instinct, or emotion.

Reason: the ability to act rationally.

Revolution Controversy: a public debate in Britain, lasting from 1789 to around 1795, about the causes and principles of the French Revolution, and how Britain should respond.

Romanticism: a cultural and intellectual movement in the late eighteenth and early nineteenth centuries, which stressed the value of nature, emotion, and freedom.

Soul: for Wollstonecraft, the spirit or basic moral humanity of a person, which lives on after that person dies.

Stereotype: a fixed idea, based on prejudice, about the character of a person who belongs to a particular group.

Subordination: the act of putting someone in a position of less power and importance than another person or group.

The Terror: a stage in the French Revolution, between 1793 and 1794, characterized by extreme violence and conflict between Revolutionary groups.

Theology: the rational study of the nature of God and religious ideas.

Treatise: a book that discusses a single subject in detail.

Universal: about or for everybody, without exception.

Utopia: an imaginary, ideal state or society.

Virtue: a behavior that is morally good; the ability to act in a morally good way.

PEOPLE MENTIONED IN THE TEXT

Chimamanda Ngozi Adichie (b. 1977) is a Nigerian author. As well as being the author of novels and short stories, she is known as an activist and speaker for feminist and anti-racist causes.

Mary Astell (1666–1731) was an English philosopher and theologian. She is best remembered for her early feminist arguments in books like *A Serious Proposal to the Ladies*, which recommends female education and the establishment of women-only schools.

Mary Beard (b. 1955) is a classicist academic at the University of Cambridge. She is also known as a British media personality and feminist activist and writer.

William Blake (1757–1827) was a Romantic poet, artist, and engraver. His work is innovative and eccentric, and reflects his involvement in radical politics and dissenting Christianity.

Susan Bordo (b. 1947) is a feminist cultural critic and philosopher at the University of Kentucky. Her work examines the influence of modern popular culture on ideas and assumptions about gender and the human body.

Edmund Burke (1729–97) was an Irish politician and journalist and the author of books on politics, history, and aesthetics. In the 1790s he fiercely opposed the French Revolution in *Reflections on the Revolution in France*, which predicted the violence of The Terror.

Judith Butler (b. 1956) is a philosopher and cultural theorist, and a professor of comparative literature at the University of California,

Berkeley. She is best known for her radical theories of gender, outlined in the books *Gender Trouble: Feminism and the Subversion of Identity* and *Bodies that Matter: On the Discursive Limits of Sex*.

Nicolas de Condorcet (1743–94) was a French political philosopher and mathematician, whose work followed the ideals of the French Enlightenment. He argued for universal education and equal political rights for all men and women.

Anne Finch (1661–1720) was Countess of Winchilsea and a poet. Many of her poems explore the role and experiences of women in seventeenth-century England.

James Fordyce (1720–96) was a Scottish minister and the writer of successful books on morality, religion, and education. His collection of *Sermons to Young Women* was very popular and influential.

William Godwin (1756–1836) was an English political philosopher, anarchist, and novelist, whose books, especially *An Enquiry Concerning Political Justice*, expressed his support of revolutionary politics and religious freedom. In 1797, he married Mary Wollstonecraft, and after her death a few months later he published a memoir of her life.

Emma Goldman (1869–1940) was a Russian anarchist activist, writer, and supporter of women's rights.

Olympe de Gouges (1748–93) was a French playwright and author of political works. These included *The Declaration of the Rights of Woman and the Female Citizen*, which attacked the failure of the French Revolution to give equal rights to women.

Mary Hays (1759–1843) was an English writer and early feminist. She was linked to the radical political circles in London, and her work describe the problems women faced in trying to live independent and rational lives.

Gilbert Imlay (1754–1828) was an American soldier, adventurer, novelist, and businessman. He had a romantic relationship with Mary Wollstonecraft while they were both visiting Paris; they famously had a daughter together although not married.

Joseph Johnson (1738–1809) was an English publisher and bookseller. He supported the causes linked to dissenting religion and radical politics, and published works by Thomas Paine, Mary Wollstonecraft, and William Godwin.

John Locke (1632–1704) was an English philosopher, seen as one of the founders of the Enlightenment. One of his most influential arguments was that humans are not born with knowledge and ideas, but gain them through their sensory experience and reason.

Catharine Macaulay (1731–91) was an English historian and political philosopher. Her ambitious *History of England* made her famous as a female intellectual, and she later wrote *Letters on Education*, which outlined her radical ideas about the status and capability of women.

Hannah More (1745–1833) was an English author, educationalist, evangelical Christian, and philanthropist. Her fiction and nonfiction works promoted both her conservative politics and her hostility to radicalism and the French Revolution.

Thomas Paine (1737–1809) was an English American political journalist and revolutionary leader. His most famous works, *Common Sense* and *Rights of Man* explained and popularized ideas of equality, freedom, and human rights, and influenced the American and French Revolutions.

Richard Price (1723–91) was a Welsh dissenting Christian minister and radical political philosopher. Most famous among his political writings was *A Discourse on the Love of our Country*, which celebrated the French Revolution and provoked Edmund Burke to write in opposition to him.

Jean-Jacques Rousseau (1712–78) was a French writer and philosopher, seen as a central figure in the French Enlightenment. His political arguments in favor of the rights of the individual helped to inspire the French Revolution, while his treatise *Émile* influenced ideas about education.

Sheryl Sandberg (b. 1969) is a billionaire and business executive, now chief operating officer of Facebook. Her book *Lean In: Women, Work, and the Will to Lead*, advises women in business to be more assertive and take on leadership roles, in order to create more equality between men and women.

Mary Shelley (1797–1851) was an English writer, best known for the novel *Frankenstein*. She was the daughter of Mary Wollstonecraft and William Godwin and the wife of Percy Bysshe Shelley.

Percy Bysshe Shelley (1792–1822) was a Romantic poet and political radical. He was linked to the London liberal circle around William Godwin, and in 1816 married Mary Godwin, the daughter of Mary Wollstonecraft and William Godwin.

Elaine Showalter (b. 1941) is an American academic whose work focuses on nineteenth- and twentieth-century literature, and the feminist intellectual tradition.

Charles Maurice de Talleyrand-Périgord (1754–1838) was a French diplomat and politician. He was an important voice in the French government after the Revolution, presenting a report recommending a program of national education that was partly adopted.

Virginia Woolf (1882–1941) was a modernist novelist and feminist. Along with her novels, she is known for nonfiction works such as *A Room of One's Own*, which advocated for women's intellectual freedom and opportunity.

William Wordsworth (1770–1850) was an English Romantic poet, whose early works were influenced by his sympathy for radical politics. His later poem *The Prelude* offers a philosophical discussion of the effects of childhood experience and education.

Malala Yousafzai (b. 1997) is a Pakistani writer and Nobel Peace Prize-winning activist for girls' education, who became internationally famous after she was shot in her head by a gunman in retaliation for her opposition to the harsh Taliban rule in the Swat Valley.

Joyce Zonana (b. 1949) is a writer and professor of English at the City University of New York. Her most famous work is the article "The Sultan and the Slave," which introduced the term "feminist orientalism" in 1993.

WORKS CITED

WORKS CITED

Astell, Mary. *Reflections upon Marriage*. In *Astell: Political Writings*, edited by Patricia Springborg. Cambridge: Cambridge University Press, 1996.

Bentley, Toni. "'Vindication': Mary Wollstonecraft's Sense and Sensibility." *New York Times*, May 29, 2005. Accessed November 24, 2015. http://www.nytimes.com/2005/05/29/books/review/vindication-mary-wollstonecrafts-sense-and-sensibility.html.

Black, Joseph, Leonard Conolly, Kate Flint, Henry Marshall Tory, Isobel Grundy, Don LePan, Roy Liuzza, Jerome J. McGann, Anne Lake Prescott, Barry V Qualls and Claire Waters (eds.). *Broadview Anthology of British Literature*. Concise Edition. London: Broadview, 2007.

Boucherett, Jessie. "Maria Edgeworth." In *English Woman's Journal* 2 (1858).

Burke, Edmund. *Reflections on the Revolution in France*. Edited by Leslie Mitchell. Oxford: Oxford World's Classics, 1999.

Caine, Barbara. "Victorian Feminism and the Ghost of Mary Wollstonecraft." In *Women's Writing* 4.2 (1997): 261–75.

Cowley, Hannah. *A Day in Turkey; or, The Russian Slaves*. London: G. G. J. and J. Robinson, 1792.

Craciun, Adriana (ed.). *Mary Wollstonecraft's* A Vindication of the Rights of Woman*: A Sourcebook*. Abingdon: Routledge, 2002.

Finch, Anne. "The Introduction." In *Major Women Writers of Seventeenth-Century England*, edited by James Fitzmaurice, Carol L. Barash, Eugene R. Cunnar, Nancy A. Gutierrez, and Josephine A. Roberts, 335–37. Ann Arbor: University of Michigan Press, 2005.

Godwin, William. *Memoirs of the Author of 'The Rights of Woman.'* Edited by Richard Holmes. London: Penguin, 1987.

Goldman, Emma. "Mary Wollstonecraft, her Tragic Life and her Passionate Struggle for Freedom." Reprinted as "Emma Goldman on Mary Wollstonecraft," edited by Alice Wexler. In *Feminist Studies* 7.1 (1981): 113–33.

Gordon, Charlotte. *Romantic Outlaws: The Extraordinary Lives of Mary Wollstonecraft and Mary Shelley*. London: Random House, 2015.

Gordon, Lyndall. *Vindication: A Life of Mary Wollstonecraft*. New York: Harper Perennial, 2005.

Guest, Harriet. *Small Change: Women, Learning, Patriotism, 1750–1810*. Chicago: University of Chicago Press, 2000.

Janes, R.M. "On the Reception of Mary Wollstonecraft's *A Vindication of the Rights of Woman*." In *Journal of the History of Ideas* 39.2 (1978): 293–302.

John Paul II. "Letter to the Bishops of the Catholic Church on the Collaboration of Men and Women in the Church and the World," May 31, 2004. Accessed November 20, 2015. http://www.vatican.va/roman_curia/congregations/cfaith/documents/rc_con_cfaith_doc_20040731_collaboration_en.html.

Johnson, Claudia L. (ed.). *The Cambridge Companion to Mary Wollstonecraft*. Cambridge: Cambridge University Press, 2002.

Kaplan, Cora. "Mary Wollstonecraft's Reception and Legacies." In *The Cambridge Companion to Mary Wollstonecraft*, edited by Claudia L. Johnson, 246–70. Cambridge: Cambridge University Press, 2002.

Kelly, Gary. *Revolutionary Feminism: The Mind and Career of Mary Wollstonecraft*. New York: St Martin's Press, 1992.

Lewis, W. S., Robert Smith and Charles H. Bennet, eds. *Horace Walpole's Correspondence with Hannah More: Lady Browne, Lady Mary Coke, Lady Hervey, Mary Hamilton (Mrs. John Dickenson), Lady George Lennox, Anne Pitt, Lady Suffolk*. Volume 31 of The Yale Edition of Horace Walpole's Correspondence. New Haven: Yale University Press, 1961.

Macaulay, Catharine. *Letters on Education: With Observations on Religious and Metaphysical Subjects* (1790). Cambridge Library Collection reissue. Cambridge: Cambridge University Press, 2014.

Paine, Thomas. *Rights of Man, Common Sense, and Other Political Writings*, edited by Mark Philp. Oxford: Oxford World's Classics, 2008.

Phillips, D.C. (ed.). *Encyclopedia of Educational Theory and Philosophy*. Los Angeles: Sage Publications, 2014.

Rousseau, Jean-Jacques. *Émile; or On Education*. Edited by P. D. Jimack. Translated by Barbara Foxley. London: Everyman, 2000.

Rowlatt, Bee. "The Original Suffragette: The Extraordinary Mary Wollstonecraft." The *Guardian*, October 5, 2015.

Showalter, Elaine. *Inventing Herself: Claiming a Feminist Intellectual Heritage*. London: Picador, 2001.

Taylor, Barbara. *Mary Wollstonecraft and the Feminist Imagination*. Cambridge: Cambridge University Press, 2003.

Tomalin, Claire. *The Life and Death of Mary Wollstonecraft*. London: Penguin, 2004.

Wollstonecraft, Mary. *The Collected Letters*. Edited by Janet Todd. London: Penguin, 2003.

———. *An Historical and Moral View of the Origin and Progress of the French Revolution*. In Wollstonecraft, *A Vindication of the Rights of Woman and A Vindication of the Rights of Men*, ed. Janet Todd, 285–372. Oxford: Oxford University Press, 2008.

———. *Mary, A Fiction and The Wrongs of Woman, or Maria*. Edited by Michelle Faubert. London: Broadview Editions, 2012.

———. "Review of Catharine Macaulay, *Letters on Education*." In *Analytical Review* 8 (1790): 241–54.

———. *Thoughts on the Education of Daughters, With Reflections on Female Conduct in the Most Important Duties of Life* (London, Joseph Johnson: 1786). LSE Digital Library. Accessed November 24 2015. http://digital.library.lse.ac.uk/.

———. *A Vindication of the Rights of Woman and A Vindication of the Rights of Men*. Edited by Janet Todd. Oxford: Oxford University Press, 2008.

Wolpert, Lewis. "Yes, It's Official, Men are from Mars and Women from Venus, and Here's the Science to Prove it." The *Telegraph*, September 14, 2014.

Woolf, Virginia. "Four Figures." In *The Common Reader*, edited by Andrew McNeillie. London: Hogarth Press, 1986.

Zonana, Joyce. "The Sultan and the Slave: Feminist Orientalism and the Structure of *Jane Eyre*." In *Signs* 18.3 (1993): 592–617.

THE MACAT LIBRARY
BY DISCIPLINE

AFRICANA STUDIES

Chinua Achebe's *An Image of Africa: Racism in Conrad's Heart of Darkness*
W. E. B. Du Bois's *The Souls of Black Folk*
Zora Neale Huston's *Characteristics of Negro Expression*
Martin Luther King Jr's *Why We Can't Wait*
Toni Morrison's *Playing in the Dark: Whiteness in the American Literary Imagination*

ANTHROPOLOGY

Arjun Appadurai's *Modernity at Large: Cultural Dimensions of Globalisation*
Philippe Ariès's *Centuries of Childhood*
Franz Boas's *Race, Language and Culture*
Kim Chan & Renée Mauborgne's *Blue Ocean Strategy*
Jared Diamond's *Guns, Germs & Steel: the Fate of Human Societies*
Jared Diamond's *Collapse: How Societies Choose to Fail or Survive*
E. E. Evans-Pritchard's *Witchcraft, Oracles and Magic Among the Azande*
James Ferguson's *The Anti-Politics Machine*
Clifford Geertz's *The Interpretation of Cultures*
David Graeber's *Debt: the First 5000 Years*
Karen Ho's *Liquidated: An Ethnography of Wall Street*
Geert Hofstede's *Culture's Consequences: Comparing Values, Behaviors, Institutes and Organizations across Nations*
Claude Lévi-Strauss's *Structural Anthropology*
Jay Macleod's *Ain't No Makin' It: Aspirations and Attainment in a Low-Income Neighborhood*
Saba Mahmood's *The Politics of Piety: The Islamic Revival and the Feminist Subject*
Marcel Mauss's *The Gift*

BUSINESS

Jean Lave & Etienne Wenger's *Situated Learning*
Theodore Levitt's *Marketing Myopia*
Burton G. Malkiel's *A Random Walk Down Wall Street*
Douglas McGregor's *The Human Side of Enterprise*
Michael Porter's *Competitive Strategy: Creating and Sustaining Superior Performance*
John Kotter's *Leading Change*
C. K. Prahalad & Gary Hamel's *The Core Competence of the Corporation*

CRIMINOLOGY

Michelle Alexander's *The New Jim Crow: Mass Incarceration in the Age of Colorblindness*
Michael R. Gottfredson & Travis Hirschi's *A General Theory of Crime*
Richard Herrnstein & Charles A. Murray's *The Bell Curve: Intelligence and Class Structure in American Life*
Elizabeth Loftus's *Eyewitness Testimony*
Jay Macleod's *Ain't No Makin' It: Aspirations and Attainment in a Low-Income Neighborhood*
Philip Zimbardo's *The Lucifer Effect*

ECONOMICS

Janet Abu-Lughod's *Before European Hegemony*
Ha-Joon Chang's *Kicking Away the Ladder*
David Brion Davis's *The Problem of Slavery in the Age of Revolution*
Milton Friedman's *The Role of Monetary Policy*
Milton Friedman's *Capitalism and Freedom*
David Graeber's *Debt: the First 5000 Years*
Friedrich Hayek's *The Road to Serfdom*
Karen Ho's *Liquidated: An Ethnography of Wall Street*

John Maynard Keynes's *The General Theory of Employment, Interest and Money*
Charles P. Kindleberger's *Manias, Panics and Crashes*
Robert Lucas's *Why Doesn't Capital Flow from Rich to Poor Countries?*
Burton G. Malkiel's *A Random Walk Down Wall Street*
Thomas Robert Malthus's *An Essay on the Principle of Population*
Karl Marx's *Capital*
Thomas Piketty's *Capital in the Twenty-First Century*
Amartya Sen's *Development as Freedom*
Adam Smith's *The Wealth of Nations*
Nassim Nicholas Taleb's *The Black Swan: The Impact of the Highly Improbable*
Amos Tversky's & Daniel Kahneman's *Judgment under Uncertainty: Heuristics and Biases*
Mahbub Ul Haq's *Reflections on Human Development*
Max Weber's *The Protestant Ethic and the Spirit of Capitalism*

FEMINISM AND GENDER STUDIES

Judith Butler's *Gender Trouble*
Simone De Beauvoir's *The Second Sex*
Michel Foucault's *History of Sexuality*
Betty Friedan's *The Feminine Mystique*
Saba Mahmood's *The Politics of Piety: The Islamic Revival and the Feminist Subject*
Joan Wallach Scott's *Gender and the Politics of History*
Mary Wollstonecraft's *A Vindication of the Rights of Women*
Virginia Woolf's *A Room of One's Own*

GEOGRAPHY

The Brundtland Report's *Our Common Future*
Rachel Carson's *Silent Spring*
Charles Darwin's *On the Origin of Species*
James Ferguson's *The Anti-Politics Machine*
Jane Jacobs's *The Death and Life of Great American Cities*
James Lovelock's *Gaia: A New Look at Life on Earth*
Amartya Sen's *Development as Freedom*
Mathis Wackernagel & William Rees's *Our Ecological Footprint*

HISTORY

Janet Abu-Lughod's *Before European Hegemony*
Benedict Anderson's *Imagined Communities*
Bernard Bailyn's *The Ideological Origins of the American Revolution*
Hanna Batatu's *The Old Social Classes And The Revolutionary Movements Of Iraq*
Christopher Browning's *Ordinary Men: Reserve Police Batallion 101 and the Final Solution in Poland*
Edmund Burke's *Reflections on the Revolution in France*
William Cronon's *Nature's Metropolis: Chicago And The Great West*
Alfred W. Crosby's *The Columbian Exchange*
Hamid Dabashi's *Iran: A People Interrupted*
David Brion Davis's *The Problem of Slavery in the Age of Revolution*
Nathalie Zemon Davis's *The Return of Martin Guerre*
Jared Diamond's *Guns, Germs & Steel: the Fate of Human Societies*
Frank Dikotter's *Mao's Great Famine*
John W Dower's *War Without Mercy: Race And Power In The Pacific War*
W. E. B. Du Bois's *The Souls of Black Folk*
Richard J. Evans's *In Defence of History*
Lucien Febvre's *The Problem of Unbelief in the 16th Century*
Sheila Fitzpatrick's *Everyday Stalinism*

Eric Foner's *Reconstruction: America's Unfinished Revolution, 1863-1877*
Michel Foucault's *Discipline and Punish*
Michel Foucault's *History of Sexuality*
Francis Fukuyama's *The End of History and the Last Man*
John Lewis Gaddis's *We Now Know: Rethinking Cold War History*
Ernest Gellner's *Nations and Nationalism*
Eugene Genovese's *Roll, Jordan, Roll: The World the Slaves Made*
Carlo Ginzburg's *The Night Battles*
Daniel Goldhagen's *Hitler's Willing Executioners*
Jack Goldstone's *Revolution and Rebellion in the Early Modern World*
Antonio Gramsci's *The Prison Notebooks*
Alexander Hamilton, John Jay & James Madison's *The Federalist Papers*
Christopher Hill's *The World Turned Upside Down*
Carole Hillenbrand's *The Crusades: Islamic Perspectives*
Thomas Hobbes's *Leviathan*
Eric Hobsbawm's *The Age Of Revolution*
John A. Hobson's *Imperialism: A Study*
Albert Hourani's *History of the Arab Peoples*
Samuel P. Huntington's *The Clash of Civilizations and the Remaking of World Order*
C. L. R. James's *The Black Jacobins*
Tony Judt's *Postwar: A History of Europe Since 1945*
Ernst Kantorowicz's *The King's Two Bodies: A Study in Medieval Political Theology*
Paul Kennedy's *The Rise and Fall of the Great Powers*
Ian Kershaw's *The "Hitler Myth": Image and Reality in the Third Reich*
John Maynard Keynes's *The General Theory of Employment, Interest and Money*
Charles P. Kindleberger's *Manias, Panics and Crashes*
Martin Luther King Jr's *Why We Can't Wait*
Henry Kissinger's *World Order: Reflections on the Character of Nations and the Course of History*
Thomas Kuhn's *The Structure of Scientific Revolutions*
Georges Lefebvre's *The Coming of the French Revolution*
John Locke's *Two Treatises of Government*
Niccolò Machiavelli's *The Prince*
Thomas Robert Malthus's *An Essay on the Principle of Population*
Mahmood Mamdani's *Citizen and Subject: Contemporary Africa And The Legacy Of Late Colonialism*
Karl Marx's *Capital*
Stanley Milgram's *Obedience to Authority*
John Stuart Mill's *On Liberty*
Thomas Paine's *Common Sense*
Thomas Paine's *Rights of Man*
Geoffrey Parker's *Global Crisis: War, Climate Change and Catastrophe in the Seventeenth Century*
Jonathan Riley-Smith's *The First Crusade and the Idea of Crusading*
Jean-Jacques Rousseau's *The Social Contract*
Joan Wallach Scott's *Gender and the Politics of History*
Theda Skocpol's *States and Social Revolutions*
Adam Smith's *The Wealth of Nations*
Timothy Snyder's *Bloodlands: Europe Between Hitler and Stalin*
Sun Tzu's *The Art of War*
Keith Thomas's *Religion and the Decline of Magic*
Thucydides's *The History of the Peloponnesian War*
Frederick Jackson Turner's *The Significance of the Frontier in American History*
Odd Arne Westad's *The Global Cold War: Third World Interventions And The Making Of Our Times*

LITERATURE

Chinua Achebe's *An Image of Africa: Racism in Conrad's Heart of Darkness*
Roland Barthes's *Mythologies*
Homi K. Bhabha's *The Location of Culture*
Judith Butler's *Gender Trouble*
Simone De Beauvoir's *The Second Sex*
Ferdinand De Saussure's *Course in General Linguistics*
T. S. Eliot's *The Sacred Wood: Essays on Poetry and Criticism*
Zora Neale Huston's *Characteristics of Negro Expression*
Toni Morrison's *Playing in the Dark: Whiteness in the American Literary Imagination*
Edward Said's *Orientalism*
Gayatri Chakravorty Spivak's *Can the Subaltern Speak?*
Mary Wollstonecraft's *A Vindication of the Rights of Women*
Virginia Woolf's *A Room of One's Own*

PHILOSOPHY

Elizabeth Anscombe's *Modern Moral Philosophy*
Hannah Arendt's *The Human Condition*
Aristotle's *Metaphysics*
Aristotle's *Nicomachean Ethics*
Edmund Gettier's *Is Justified True Belief Knowledge?*
Georg Wilhelm Friedrich Hegel's *Phenomenology of Spirit*
David Hume's *Dialogues Concerning Natural Religion*
David Hume's *The Enquiry for Human Understanding*
Immanuel Kant's *Religion within the Boundaries of Mere Reason*
Immanuel Kant's *Critique of Pure Reason*
Søren Kierkegaard's *The Sickness Unto Death*
Søren Kierkegaard's *Fear and Trembling*
C. S. Lewis's *The Abolition of Man*
Alasdair MacIntyre's *After Virtue*
Marcus Aurelius's *Meditations*
Friedrich Nietzsche's *On the Genealogy of Morality*
Friedrich Nietzsche's *Beyond Good and Evil*
Plato's *Republic*
Plato's *Symposium*
Jean-Jacques Rousseau's *The Social Contract*
Gilbert Ryle's *The Concept of Mind*
Baruch Spinoza's *Ethics*
Sun Tzu's *The Art of War*
Ludwig Wittgenstein's *Philosophical Investigations*

POLITICS

Benedict Anderson's *Imagined Communities*
Aristotle's *Politics*
Bernard Bailyn's *The Ideological Origins of the American Revolution*
Edmund Burke's *Reflections on the Revolution in France*
John C. Calhoun's *A Disquisition on Government*
Ha-Joon Chang's *Kicking Away the Ladder*
Hamid Dabashi's *Iran: A People Interrupted*
Hamid Dabashi's *Theology of Discontent: The Ideological Foundation of the Islamic Revolution in Iran*
Robert Dahl's *Democracy and its Critics*
Robert Dahl's *Who Governs?*
David Brion Davis's *The Problem of Slavery in the Age of Revolution*

Alexis De Tocqueville's *Democracy in America*
James Ferguson's *The Anti-Politics Machine*
Frank Dikotter's *Mao's Great Famine*
Sheila Fitzpatrick's *Everyday Stalinism*
Eric Foner's *Reconstruction: America's Unfinished Revolution, 1863-1877*
Milton Friedman's *Capitalism and Freedom*
Francis Fukuyama's *The End of History and the Last Man*
John Lewis Gaddis's *We Now Know: Rethinking Cold War History*
Ernest Gellner's *Nations and Nationalism*
David Graeber's *Debt: the First 5000 Years*
Antonio Gramsci's *The Prison Notebooks*
Alexander Hamilton, John Jay & James Madison's *The Federalist Papers*
Friedrich Hayek's *The Road to Serfdom*
Christopher Hill's *The World Turned Upside Down*
Thomas Hobbes's *Leviathan*
John A. Hobson's *Imperialism: A Study*
Samuel P. Huntington's *The Clash of Civilizations and the Remaking of World Order*
Tony Judt's *Postwar: A History of Europe Since 1945*
David C. Kang's *China Rising: Peace, Power and Order in East Asia*
Paul Kennedy's *The Rise and Fall of Great Powers*
Robert Keohane's *After Hegemony*
Martin Luther King Jr.'s *Why We Can't Wait*
Henry Kissinger's *World Order: Reflections on the Character of Nations and the Course of History*
John Locke's *Two Treatises of Government*
Niccolò Machiavelli's *The Prince*
Thomas Robert Malthus's *An Essay on the Principle of Population*
Mahmood Mamdani's *Citizen and Subject: Contemporary Africa And The Legacy Of Late Colonialism*
Karl Marx's *Capital*
John Stuart Mill's *On Liberty*
John Stuart Mill's *Utilitarianism*
Hans Morgenthau's *Politics Among Nations*
Thomas Paine's *Common Sense*
Thomas Paine's *Rights of Man*
Thomas Piketty's *Capital in the Twenty-First Century*
Robert D. Putman's *Bowling Alone*
John Rawls's *Theory of Justice*
Jean-Jacques Rousseau's *The Social Contract*
Theda Skocpol's *States and Social Revolutions*
Adam Smith's *The Wealth of Nations*
Sun Tzu's *The Art of War*
Henry David Thoreau's *Civil Disobedience*
Thucydides's *The History of the Peloponnesian War*
Kenneth Waltz's *Theory of International Politics*
Max Weber's *Politics as a Vocation*
Odd Arne Westad's *The Global Cold War: Third World Interventions And The Making Of Our Times*

POSTCOLONIAL STUDIES

Roland Barthes's *Mythologies*
Frantz Fanon's *Black Skin, White Masks*
Homi K. Bhabha's *The Location of Culture*
Gustavo Gutiérrez's *A Theology of Liberation*
Edward Said's *Orientalism*
Gayatri Chakravorty Spivak's *Can the Subaltern Speak?*

PSYCHOLOGY

Gordon Allport's *The Nature of Prejudice*
Alan Baddeley & Graham Hitch's *Aggression: A Social Learning Analysis*
Albert Bandura's *Aggression: A Social Learning Analysis*
Leon Festinger's *A Theory of Cognitive Dissonance*
Sigmund Freud's *The Interpretation of Dreams*
Betty Friedan's *The Feminine Mystique*
Michael R. Gottfredson & Travis Hirschi's *A General Theory of Crime*
Eric Hoffer's *The True Believer: Thoughts on the Nature of Mass Movements*
William James's *Principles of Psychology*
Elizabeth Loftus's *Eyewitness Testimony*
A. H. Maslow's *A Theory of Human Motivation*
Stanley Milgram's *Obedience to Authority*
Steven Pinker's *The Better Angels of Our Nature*
Oliver Sacks's *The Man Who Mistook His Wife For a Hat*
Richard Thaler & Cass Sunstein's *Nudge: Improving Decisions About Health, Wealth and Happiness*
Amos Tversky's *Judgment under Uncertainty: Heuristics and Biases*
Philip Zimbardo's *The Lucifer Effect*

SCIENCE

Rachel Carson's *Silent Spring*
William Cronon's *Nature's Metropolis: Chicago And The Great West*
Alfred W. Crosby's *The Columbian Exchange*
Charles Darwin's *On the Origin of Species*
Richard Dawkin's *The Selfish Gene*
Thomas Kuhn's *The Structure of Scientific Revolutions*
Geoffrey Parker's *Global Crisis: War, Climate Change and Catastrophe in the Seventeenth Century*
Mathis Wackernagel & William Rees's *Our Ecological Footprint*

SOCIOLOGY

Michelle Alexander's *The New Jim Crow: Mass Incarceration in the Age of Colorblindness*
Gordon Allport's *The Nature of Prejudice*
Albert Bandura's *Aggression: A Social Learning Analysis*
Hanna Batatu's *The Old Social Classes And The Revolutionary Movements Of Iraq*
Ha-Joon Chang's *Kicking Away the Ladder*
W. E. B. Du Bois's *The Souls of Black Folk*
Émile Durkheim's *On Suicide*
Frantz Fanon's *Black Skin, White Masks*
Frantz Fanon's *The Wretched of the Earth*
Eric Foner's *Reconstruction: America's Unfinished Revolution, 1863-1877*
Eugene Genovese's *Roll, Jordan, Roll: The World the Slaves Made*
Jack Goldstone's *Revolution and Rebellion in the Early Modern World*
Antonio Gramsci's *The Prison Notebooks*
Richard Herrnstein & Charles A Murray's *The Bell Curve: Intelligence and Class Structure in American Life*
Eric Hoffer's *The True Believer: Thoughts on the Nature of Mass Movements*
Jane Jacobs's *The Death and Life of Great American Cities*
Robert Lucas's *Why Doesn't Capital Flow from Rich to Poor Countries?*
Jay Macleod's *Ain't No Makin' It: Aspirations and Attainment in a Low Income Neighborhood*
Elaine May's *Homeward Bound: American Families in the Cold War Era*
Douglas McGregor's *The Human Side of Enterprise*
C. Wright Mills's *The Sociological Imagination*

Thomas Piketty's *Capital in the Twenty-First Century*
Robert D. Putman's *Bowling Alone*
David Riesman's *The Lonely Crowd: A Study of the Changing American Character*
Edward Said's *Orientalism*
Joan Wallach Scott's *Gender and the Politics of History*
Theda Skocpol's *States and Social Revolutions*
Max Weber's *The Protestant Ethic and the Spirit of Capitalism*

THEOLOGY

Augustine's *Confessions*
Benedict's *Rule of St Benedict*
Gustavo Gutiérrez's *A Theology of Liberation*
Carole Hillenbrand's *The Crusades: Islamic Perspectives*
David Hume's *Dialogues Concerning Natural Religion*
Immanuel Kant's *Religion within the Boundaries of Mere Reason*
Ernst Kantorowicz's *The King's Two Bodies: A Study in Medieval Political Theology*
Søren Kierkegaard's *The Sickness Unto Death*
C. S. Lewis's *The Abolition of Man*
Saba Mahmood's *The Politics of Piety: The Islamic Revival and the Feminist Subject*
Baruch Spinoza's *Ethics*
Keith Thomas's *Religion and the Decline of Magic*

COMING SOON

Chris Argyris's *The Individual and the Organisation*
Seyla Benhabib's *The Rights of Others*
Walter Benjamin's *The Work Of Art in the Age of Mechanical Reproduction*
John Berger's *Ways of Seeing*
Pierre Bourdieu's *Outline of a Theory of Practice*
Mary Douglas's *Purity and Danger*
Roland Dworkin's *Taking Rights Seriously*
James G. March's *Exploration and Exploitation in Organisational Learning*
Ikujiro Nonaka's *A Dynamic Theory of Organizational Knowledge Creation*
Griselda Pollock's *Vision and Difference*
Amartya Sen's *Inequality Re-Examined*
Susan Sontag's *On Photography*
Yasser Tabbaa's *The Transformation of Islamic Art*
Ludwig von Mises's *Theory of Money and Credit*

The Macat Library By Discipline